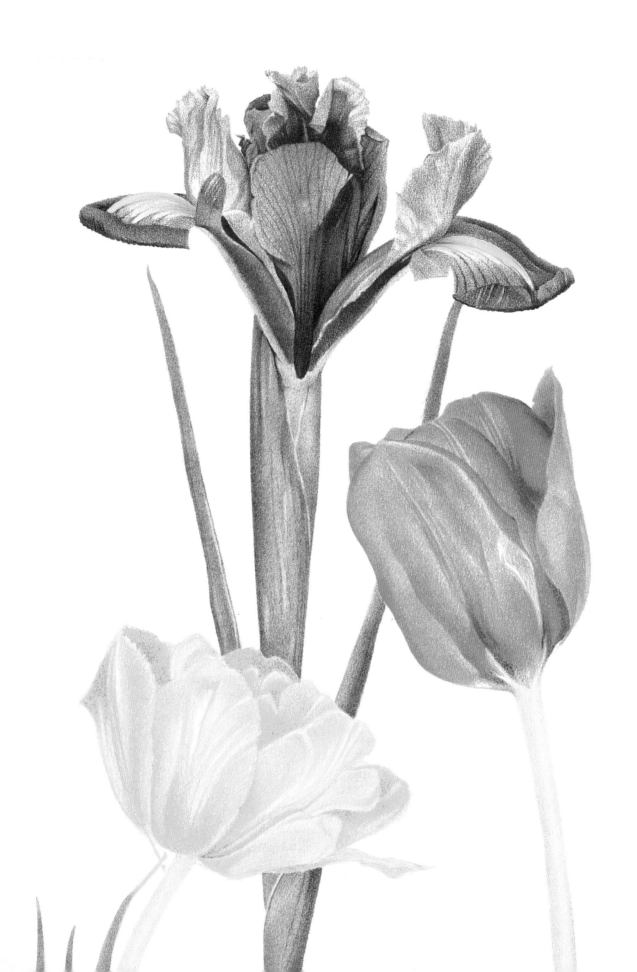

THE COMPLETE GUIDE TO

COLOURED

PENCIL

TECHNIQUES

BEVERLEY JOHNSTON

David & Charles

A DAVID & CHARLES BOOK

First published in the UK in 2003

Copyright © Beverley Johnston 2003

Distributed in North America
by F&W Publications, Inc.
4700 East Galbraith Road
Cincinnati, OH 45236
1-800-289-0963

A catalogue record for this book is available from the
British Library.

ISBN 0 7153 1407 6 hardback
ISBN 0 7153 1408 4 paperback (USA only)

Printed in Singapore by KHL Printing Co Pte Ltd
for David & Charles
Brunel House Newton Abbot Devon

Senior Editor Freya Dangerfield
Senior Designer Prudence Rogers
Production Controller Kelly Smith

Visit our website at www.davidandcharles.co.uk

David & Charles books are available from all good bookshops;
alternatively you can contact our Orderline on (0)1626 334555
or write to us at FREEPOST EX2110, David & Charles Direct,
Newton Abbot, TQ12 4ZZ (no stamp required UK mainland).

Contents

Introduction

More often than not, when you mention to people that you enjoy using coloured pencils, they will look at you in bewilderment, because they first and foremost associate them with drawing tools for children, the ones they progress on to after using chunky wax crayons.

Even some art groups discourage their use, prompting their members to progress to more 'serious' mediums, such as watercolours or oils. Coloured pencils have been underestimated as a fine-art medium for years, yet they are a wonderful, exciting and versatile medium to use, capable of producing art of a serious nature as well as the fun, bright, sketchy graphic illustrations that are associated with the commercial art and graphics industry.

Of course, the coloured pencils that I use are of a far superior quality than the ones used by children. There are a number of manufacturers producing them today, and the spectrum of colours on offer is vast, with some boxes containing up to 120 different colours. Even now, when I open a new box of pencils for the first time it never ceases to wow me!

The other reason why coloured pencils have been overshadowed as a fine-art medium is because of problems associated with lightfastness. Nobody wants to produce a piece of artwork and then risk having it fade once it's up on a wall, but coloured-pencil artwork is no more at risk then a watercolour. Manufacturers are striving to produce lightfast colours, and there are also ways of protecting work once it is finished.

As with any art medium, coloured pencils do take some time to master, but with a little patience and practice a wide range of effects and textures can be achieved, giving scope for a variety of compositions and pictures to be produced. The aim of this book is to show you the versatility of coloured pencils, and although I really have just one technique (a combination of blending and layering of colours one upon another, drawing in lines and marks where necessary), I can use it to create and achieve a complete range and variety of work, from intricate studies of natural history subject matter to animal portraits.

How to use this book

Throughout the book I will take you through a series of easy-to-follow demonstrations and projects, using simple step-by-step instructions. You will be guided in how to use your coloured pencils successfully, enabling you to draw your own favourite subject

4

matter. Some are geared for the beginner, others for the more advanced, so whatever your ability, there should be a project to suit you.

You will also find helpful tips, hints and suggestions on how to improve your general drawing, observation and composition skills, and the 'tricks' I use to complete my work.

Producing art should always be fun, but equally can be frustrating and demanding, especially when you encounter problems such as inadequate reference material or an uninteresting composition; but with a little thought and forward planning, your work can be improved upon and the end results can be more rewarding.

The second part of the book concentrates on the projects. Each of these begins with the reference photo from which I worked. You can choose to work on it at the same scale as shown, or you can enlarge it by scanning it on to a computer or enlarging it on a photocopier. Ideally, the colours to use will be the same as those listed, but don't worry if the brand I've used is different to the ones you have – just simply match your colours to the colour key illustrated, then work from the step-by-step instructions of the demonstration. But remember, every artist is unique, and no two artists will produce the same results, even if working from the same reference, so don't worry if your picture differs in style from mine – your individuality will simply be shining through. I hope you will then attempt some pictures of your own, based on similar reference material.

A word about colour

What you won't find in this book are pages and pages of colour theory, the reason being that I have never had to make use of the colour wheel for producing my work. With coloured pencils the blending is done on the paper, not on a palette, and because manufacturers produce such a spectrum of colours, I simply use my eyes and intuition for selecting the colours I need. If initially you find selecting colours daunting when it comes to producing your own work, the simplest way of getting the colours right is to scribble small patches on to a piece of paper and check them against your reference. In time you will have a better understanding of how your pencils work, which colours to lay upon which, and whether to use light or dark colours first.

Writing this, my first, book, has been a wonderful and rewarding experience. I hope that the work you see here will inspire you to have a go at producing your own coloured-pencil pictures, and that you will find the book both helpful and useful, a continuing source of reference and enjoyment.

MATERIALS

Brands and makes
Each demonstration lists the brand and pencil number of the colours used (the names may change). If you don't have the brand named, substitute your pencils for those listed, matching each one as near as possible to the colour key shown.

Coloured pencils need very few materials and accessories, making them an extremely useful medium for working in small and confined spaces.

I purchase most of my materials from mail-order art companies (art magazines list suppliers). This is for the convenience of being able to order from my home, and also, because I tend to buy in bulk, it is a cheap way to buy. Good art shops also carry most of the materials used in this book, or will be able to order them for you.

Pencils
There are a number of major art manufacturers making artists'-quality coloured pencils today, and most brands are available in over 100 colours. For the majority of my work I prefer to use oil- or wax-based, non-watersoluble ones, although I do use watersoluble coloured pencils occasionally – and they can be used in exactly the same way as demonstrated in this book. The major difference is that oil- and wax-based brands have a slightly creamier texture, and can be blended and layered easily.

Over the last couple of years I have tried most makes, and I do have my favourites. I've also found the best papers to suit my technique. The important thing for those new to coloured pencils is to try different pencils with different papers until you find a combination that suits your technique. Most of the popular brands come in sets, starting with 12 colours, and most are also available singly from good art shops and mail-order art companies, so before investing in a complete set, try just a few of them out first.

Looking after your pencils
The coloured pencils we're most familiar with have a coloured core covered in an outer wooden casing. Although they appear sturdy and hardwearing, try not to drop them, as they can break quite easily internally, rendering them unusable.

A constantly sharpened pencil will end up as an unusable stub, becoming uncomfortable to hold and resulting in a lot of natural wastage. Thankfully, there are pencil extenders available – I use one made by Lyra Rembrandt, which holds the pencil securely, thus giving additional hours of use.

Because of limited space, I only keep my pencils out whilst they're being used. When they are not, I store them away in inexpensive boxes purchased from hobby or DIY stores.

Pencil sharpeners

Sharp pencils are a necessity for me, therefore a pencil sharpener is the most important accessory that I use and replace on a regular basis.

I find the battery-operated ones to be the best value for money, giving sufficiently well-sharpened pencils without stress on my wrist and elbow. There are also electric mains sharpeners. but these tend to be quite expensive. The cheapest sharpeners are the traditional, hand-held metal ones, commonly used by students. Unfortunately these blunt quite quickly, although when new they give excellent sharp points. I therefore buy the ones with replacement blades and use them in conjunction with my battery-operated sharpener.

Different pencil brands differ in size, as do sharpeners. When buying a new sharpener, it's worth taking a pencil with you to check that it will fit.

Whichever sharpener you decide to use, keep it well away from your work because the pencil dust can mark and stain the paper. If you find pencil dust on your work, don't blow at it – keep a large, soft, clean, dry watercolour brush nearby and use this for gently brushing unwanted pencil dust away.

I also occasionally use emery paper for filing the pencils to a fine point. Derwent produce a small emery pad which contains small pieces of emery paper that can be disposed of once the pad is full. You can also use a piece of extra-fine sandpaper to get a fine point.

Erasers

White kneadable putty erasers are my preferred ones; some coloured-pencil artists use Blu-Tack or White Tack. I keep the eraser moulded to a fine point, which makes it ideal for lifting out small areas. When the tip has become dirtied and unusable, I simply pull it off and throw it away. To prevent damage to the paper and drawing, dab to remove unwanted marks – don't rub.

I occasionally use a hard plastic art eraser if I've made a drastic mistake and need to remove a large amount of pencil (see page 93). I only do this in extreme cases, which is why I spend time carefully planning my work, to prevent too many mistakes.

I also have a hand-held battery-operated eraser. The actual eraser is similar in size and shape to those seen at the end of some graphite pencils. It can be used on its own or with small metal templates to lift off pencil marks to create certain shapes.

Papers

Artists often refer to their papers as 'supports', so if you come across this word or hear other artists using it, you'll

know what they mean. Throughout the book, however, I use the word 'paper'.

As with pencils, the paper you use is very much a personal choice. The tooth (texture) of the paper is important for coloured-pencil drawings. I use smooth white drawing papers, HP (Hot-pressed) watercolour papers and NOT (slightly rough, Not Hot-pressed) watercolour papers, depending on the subject.

Throughout the book three papers have been used: smooth white cartridge paper, Fabriano 5 HP paper and Canson Bristol paper. If the papers listed aren't available in your local art shop, ask for similar samples of paper to try – any heavy, smooth, white cartridge paper should suffice; the substitute for Fabriano 5 HP should be a heavy, white HP watercolour paper; and the substitute for the Canson Bristol paper should be any white Bristol paper or board. If you have a selection of papers, try them all and find the best ones for you.

Drawing boards

I prefer to work in an upright position, because it is more comfortable and doesn't cause neckache. I have two small drawing boards, a cheap tabletop version and an expensive combined kneeling chair with drawing board. The tabletop board can be used on any table, making it ideal for use in small or confined spaces, such as a kitchen or dining room.

Tracing paper and transparency film

I use tracing paper on nearly every picture, both for tracing out the initial outline of my reference, and as a guide for checking the

positions of features as the picture is progressing. I also use it for covering my work when I leave it for long periods.

I don't use the traditional method of indenting the image through tracing paper, because this can damage the tooth and cause unwanted lines that are impossible to remove.

After initially copying the outline and main features of my reference photo out on to the tracing paper, using an HB pencil, I place it upon the paper I'm going to be using.

Then, using my chosen pencil, usually a mid-tone colour to match my subject, I lift the tracing and place the pencil lightly on to the paper below, resting the tracing back down. I then follow the image that's on the tracing paper, copying it out on to the paper below. The pencil is 'sandwiched' between the two papers.

Once I've finished, I tidy up the drawing, keeping my tracing nearby so that I can check the positioning of features as the drawing progresses.

I use tracing paper simply to save time. Even the best-traced image in the world will not result in a wonderfully drawn picture; the success of the finished piece still relies on the skill of the artist.

I use transparency film in a similar way to tracing paper, copying my reference photo on to my computer and printing it out in full colour on to the film. I then use it as a guide for checking the positioning of all features by placing it over the picture while working.

Lightboxes

Lightboxes are another tool useful for tracing out initial outlines of images, but

they can be quite expensive to buy. A cheap and simple lightbox is a window. When the sun is bright you can tack a photo on to a clean, dry window, then trace from it.

Masking tape

I use low-tack, acid-free masking tape for holding paper in place on my drawing board. This tape is quite expensive but it is easy to remove without ripping the paper, and it doesn't contain damaging glues that can stain and damage the paper with long-term use. If you only have normal masking tape, remove some of the adhesive by gently dabbing the tape against some cloth. This way, it's less likely to damage the paper.

Dissolving pencil marks

As mentioned previously, the pencils used for the projects in this book are non-watersoluble. Occasionally, however, artists decide to dissolve some of the pigment when they want an initial flat, even layer of colour, so that the entire surface of the paper is covered and none of the tooth is left showing. Traditionally, the only substances available have been white spirit and turpentine, but now there is Zest-it, a non-toxic, safe, non-flammable alternative, that can be used for dissolving oil and wax pencils.

Protecting your work

While working, it's important to keep the area around you clean. Keep all food and drink well away from your drawing, as it's impossible to remove grease and stains. For added protection, carefully tack all your work on to a piece of cardboard. This also helps to keep the paper stiff, preventing damage from bends and creases.

I use a clean sheet of paper to rest on so that I don't smudge or dirty the drawing. When I leave my work, even for short periods, I cover it with a sheet of tracing paper.

Fixing

Not only do I use fixative to fix all of my work once completed, I occasionally use it while working, both to fix colours between layers and to get back some of the tooth on overworked areas for continued working. Use a good-quality fixative suitable for coloured pencil work (pastel fixatives are usually suitable).

The fixative I use contains UV filters to help filter out harmful ultraviolet rays. The most important thing is to keep pictures away from harmful light and heat sources, especially direct sunlight. Coloured-pencil pictures should be treated like any other precious work of art or fine piece of furniture – sunlight bleaches and damages, so keep your drawings away from it! If you work under fluorescent light, keep your work covered when you are not working on it.

For added protection I have my work framed behind conservation-quality glass, which also contains UV filters.

GETTING TO KNOW YOUR PENCILS

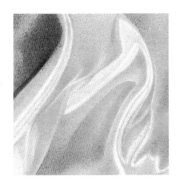

One of the wonderful things about coloured pencils is that because manufacturers produce such large ranges, the colours are easy to pick and no complicated mixing is involved.

Where possible, I pick pencils nearest in colour to my chosen subject and then choose other shades and colours to add warmth or depth of tone, or just to lift the overall colour – black is one colour that benefits from having another colour laid down first, for example, otherwise it can appear dull and flat.

When starting a new drawing I lay my pencils out in front of my reference and choose my palette by trying the pencils on a piece of paper to see how well they match. Once they are chosen, I keep a colour key by my side. This makes it easier for me to carry on drawing after taking a long break, and to know that I am using the right colours.

In time you will find favourite pencil brands and papers that work well for you. To get to that stage, however, you may need to try a number of different combinations. Most of the major pencil brands are available singly, so you don't have to spend a lot of money to try them.

To find out which combinations were right for me, especially when buying new papers, I found it useful to try my pencils out on a sample piece of paper first. So, if you are going to purchase new paper, don't be afraid to ask the sales assistant if you can try it first. I still take my favourite pencils with me to do just that when looking to buy new paper.

Technique

Creating realistic-looking subject matter, a spectrum of colours, shades and tones, and a variety of textures and effects, relies on how the pencils are applied to the paper while avoiding the danger of overworking and spoiling the picture.

My technique is a combination of delicate, subtle and evenly applied layers of colour combined with individual lines and marks where necessary. By building up these layers, adding and blending other colours where necessary, I can create a multitude of effects. For this reason it often takes me in excess of ten hours to complete even a small pet portrait, but I enjoy seeing the drawing grow in front of me and find the whole process of drawing both rewarding and therapeutic.

I also work on more than one drawing at any given time, so that I can have a rest from the more complicated drawings. I can then come back to each drawing refreshed and more likely to notice mistakes; because the layers are light, mistakes can quite easily be corrected.

To achieve the light layers I rest my hand upon a protective sheet of paper on the surface. That way I can control the amount of pressure through the pencil. I then apply the pencil in small movements in all directions, tickling the surface very lightly with the edge of the pencil point. By adding more layers and applying more pressure when necessary, I can vary the depth of colour and tone. If the pressure is too hard too soon, the surface of the

paper, the tooth, can become damaged, making it difficult to add further layers of colour. I work mainly from lights to darks, reserving the white of the paper for white and light-coloured areas.

Layering and blending pencils

If you are new to coloured pencils, or want to improve your own blending and layering technique before attempting a project, there are some simple exercises you can do. There is no right or wrong way in which order colours should be blended together; it depends on what the final colour is to be, and getting it right comes with experience. It's therefore a good idea to try out different combinations on a spare piece of paper beforehand.

Exercise 1: applying pencil layers

The first exercise is to create three depths of colour by applying one coloured pencil to a small area. The objective of the exercise is to achieve an even, flat area of colour that doesn't have any prominent visible pencil marks showing. You can do the exercise using three separate squares, or simply reapply the pencil in one square.

After layer one you should have a light (20 per cent) tint of the pencil colour.

After layer two you should have a mid (50 per cent) tint of the pencil colour.

After layer three you should have a 70 per cent tint of colour.

Applied solid, the colour is 100 per cent, at its colour maximum.

Exercise 2: graduating

This exercise uses one colour which, by varying the pressure, is graduated and then faded away.

Apply pressure at the left, and then gradually release the pressure so that the pencil gradually lightens until at the right it can barely be seen.

Exercise 3: blending two pencils together

Blending two or more pencils together creates additional colours or different tones, shades or hues. So even if you have, say, five different colours of orange in your pencil box, you may need to change the colour slightly, to make it warmer or cooler, darker or lighter, or you may not have the exact colour of orange you need.

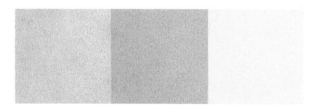

This exercise shows you how red and yellow are blended together to create orange. A very light layer of yellow is laid down first, a light layer of red is then added, followed by another light layer of yellow.

CREATING FORM

Practising with a single colour can help you to improve your blending, layering and graduating skills, as you have to rely totally on a variety of different pressures to achieve a number of different tones of colour and individual marks.

The subject for this exercise is an orange, for which I used Faber-Castell Polychromos Tangerine. As well as the overall orange colour, there were white highlights, dark dots and marks upon the skin, and the overall three-dimensional shape had to be captured. By observing and paying close attention to details, such as textures and how light falls upon the surface of your subject, you are learning more about your subject matter. This in turn will help you to improve your drawing skills.

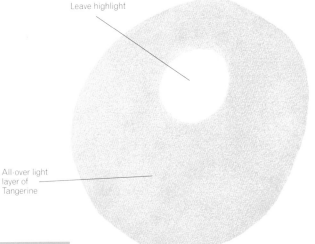

Leave highlight

All-over light layer of Tangerine

1 After sketching the outline of the orange I drew in a circle to depict the area of white highlight, which was left as the white of the paper at this stage. I then started to block in the rest of the area with a *very light layer* of Tangerine to create a mid-tone colour.

MATERIALS

Pencils
Faber-Castell Polychromos
Tangerine No. III

Paper
Smooth Cartridge Paper
210gsm (110lb)

Additional equipment
Kneaded putty eraser
Pencil sharpener

2 I began to draw in the characteristic orange-peel skin, starting with the highlight area. A sharp point was a necessity, and I literally dotted and drew the marks in using firm pressure, which created the dark tone. I then used lighter pressure to block in the colour surrounding these dots.

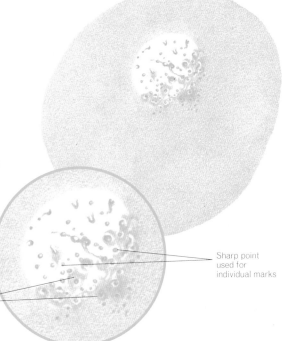

Sharp point used for individual marks

Varied pressure used for surrounding colour

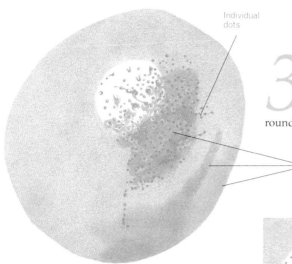

Individual dots

Varied tones create rounded and three-dimensional shape

3 Using a variety of pressures I started to create both the different tones of colour and the characteristics of the skin necessary to give the orange its rounded shape.

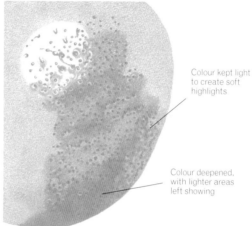

Colour kept light to create soft highlights

Colour deepened, with lighter areas left showing

4 I deepened the colour along the outer edge to create the round contours, leaving some of the light tones showing along the bottom right-hand side of the orange to create a soft highlight where the light reflects off the skin.

Tip

If you want to draw another object using just one colour, make sure you choose a pencil that is strong enough in colour to create a range of tones, from light to dark. It's far easier to vary the pressure of a stronger colour to create the light tones, then it is to create darker tones from a light pencil – if the pigment is naturally light, no amount of pressure will increase the depth of colour, and you can end up damaging the surface of the paper.

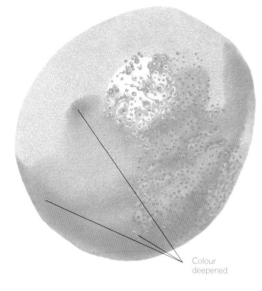

Colour deepened

5 I continued to block in the colour to develop the shape and contours of the orange still further, increasing pressure to deepen the tone of colour.

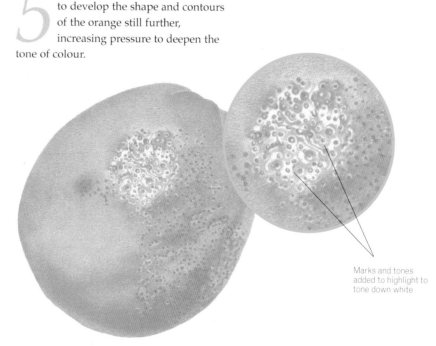

Marks and tones added to highlight to tone down white

6 I deepened the colour where necessary, such as on the lower half of the orange and the top edge. I finally added some orange marks to parts of the highlight to tone down the stark white of the paper, then added dots to complete the look of the skin.

BLENDING, LAYERING AND GRADUATING COLOURS

Having worked on a single-colour object in the previous exercise, the next stage is to produce a drawing using a limited palette of just three colours. This exercise will help you to develop the layering and graduating techniques learnt in the previous exercises. By keeping to a limited palette you will learn more about creating additional colours from layering and blending two colours together – in this case, creating an orange-red from layering Dark Red on to Light Green.

Your observation skills will also improve and you will start to see the subtle colour changes, tones and textures you might otherwise have taken for granted. You will also learn more about drawing a three-dimensional object to make it look more realistic and convincing. The subject of this exercise – an apple – will encourage you to start blending, layering and graduating the three colours of choice; and the exercise itself will help you to look more closely at the different characteristics of your subject that you should be picking out.

I chose a traditional red and green eating apple for this exercise. If you look carefully you will see that the red of the apple is not always solid – in places it appears speckled and mottled, especially on the yellow-green areas. There are stronger, darker red marks which follow the contours of the apple's shape, as well as tiny yellow-green specks on the skin. By capturing these marks and characteristics you will create a realistic-looking apple.

1 I first sketched the outline of the apple using Dark Red. The next step was to block in the entire area *very lightly* with a base layer of Lemon Cadmium, leaving strong highlights showing as the white of the paper.

I then started to apply the tiny circles of yellow-green specks by drawing their outlines in Dark Red; a sharp point was essential for drawing these. Next, I started to block in the red and green, again using a *very light* layer of Dark Red and Light Green.

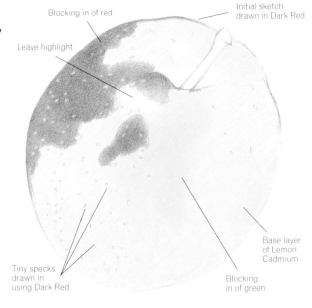

Blocking in of red

Initial sketch drawn in Dark Red

Leave highlight

Tiny specks drawn in using Dark Red

Base layer of Lemon Cadmium

Blocking in of green

2 I continued to block in the red and green areas, layering and graduating them together to create orange-red areas. The small yellow-green areas became more apparent as the colours were blocked in. Because the orange area holds the mottled or speckled markings, I next applied Dark Red using small circular movements, over the Light Green, and lifting the pencil off the paper quickly to create the markings.

I now applied more pressure to those areas of the apple where I considered more shape and definition were required, for example, around the recessed area of the stalk. I also began to draw in the lines and marks necessary to depict the contours and the round, three-dimensional shape.

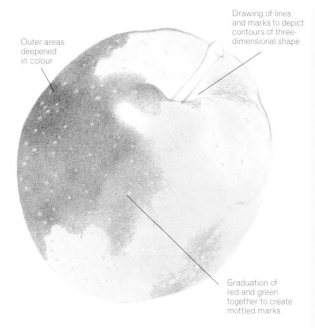

Outer areas deepened in colour

Drawing of lines and marks to depict contours of three-dimensional shape

Graduation of red and green together to create mottled marks

Creating shine

A smooth paper is essential to create a solid, shiny looking object, as the tooth of the paper needs to be almost non-existent, so that the paper doesn't show through the pencil layers.

The shine can be achieved in a number of ways. I rely on continuous layering of pencil colours to build up the solid look of an object. Used in this way, the pencils are burnished (rubbed together) upon each other until the tooth of the paper is sufficiently filled with pigment, creating a natural shine. By leaving highlights showing as the white of the paper, the end result looks even more realistic.

There are other ways to create a smooth shiny finish. One is to use a colourless blender such as Lyra 'Splender', which you use to 'rub' the colours into each other. You can also use a cotton bud or tissue to rub the pencil layers together. Another method of achieving a flat, even layer of colour is to dissolve an initial layer of pencil with white spirit or Zest-it (see page 9).

An area may be over-worked when layers are burnished together resulting in a complete loss of tooth, where the paper is resistant to further layers of pencil. In this case, spray the drawing with a fine coat of fixative, allow to dry, then continue working.

Continuation of deepening areas of colour

All marks are now drawn in

Layer of Lemon Cadmium added

3 Having blocked in all areas of red and green, and drawn in all the lines and marks, I gave the green and orange areas of the apple a *very light* layer of Lemon Cadmium. This adds warmth and enriches this area of colour, and starts to burnish (blend) the colours together to create the shine. I did not add it to the stronger outer areas of red because I wanted these areas to appear cooler in comparison with other areas.

4 I continued to strengthen the areas of colour and to deepen areas of shadow to give the apple its solid, round appearance. Where the light falls upon the side of the apple, creating soft highlights, I added a *light* layer of Lemon Cadmium. I then darkened the shadow areas, first with a layer of Light Green, then with a *very light* layer of Dark Red. I alternated between the yellow and red to burnish the colours together.

For the stalk, I first applied a *very light* layer of Light Green then a layer of Dark Red, alternating between the two until I achieved a subtle brown colour.

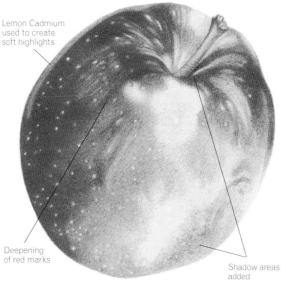

Lemon Cadmium used to create soft highlights

Deepening of red marks

Shadow areas added

SMOOTH TEXTURES: WOOD

Drawing a small piece of smooth wood as a study, such as part of a floorboard, is a good exercise in blending pencils together to create a flat and even smooth effect, but without the need to burnish or blend the colours together using any other tool.

In the exercise on these pages the primary idea is to apply many light layers of pencil, so as not to build up too much wax residue; if this does occur, it becomes difficult – and ultimately frustrating – to blend any further layers of colour on to one another.

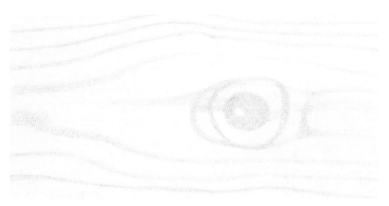

1 I blocked in a base layer of Burnt Ochre using quite large pencil strokes, as it wasn't necessary to create a tight, even layer of pencil at this stage. I then drew in the pattern of the wood using Raw Umber.

MATERIALS

Pencils
Faber-Castell Polychromos
Burnt Ochre No. 187
Raw Umber No. 180
Brown Ochre No. 182
Light Sepia No. 177
Orange Yellow No. 109

Paper
Smooth Cartridge Paper
210gsm (100lb)

Additional equipment
Pencil sharpener

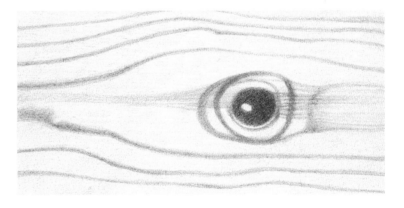

2 I deepened the colour of the markings using Raw Umber, and then softened the colour with Brown Ochre, varying the pencil pressure so as to make the edge of the markings soft and uneven. For the knot, I added a layer of Light Sepia on top of the Raw Umber. I then added a layer of Burnt Ochre over the whole study.

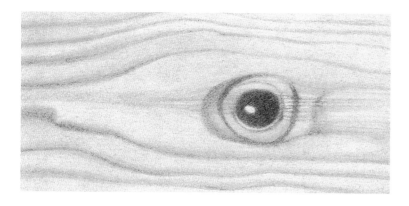

3 To give the wood a golden tint, I added a *light* layer of Orange Yellow over the whole study. I then applied another *light* layer of Burnt Ochre over the markings to brighten up their colour. I graduated the colour over the rest of the wood to create two shades of orange.

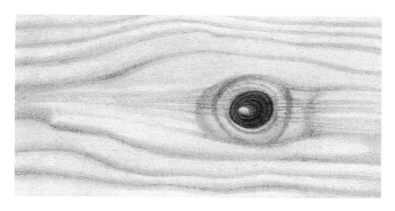

Tip
If you intend to include a smooth piece of wood in a picture, decide beforehand if the wood is to be strong and dominant in the drawing. If it is, choose a piece with interesting grain and knots. If it's to be more subtle, choose a piece with a lighter grain and less knots.

4 The final stage was to deepen the colours where necessary, such as on the knot and some of the stronger markings. I also blended a little more Brown Ochre over some of the areas.

Q I want to draw a still life that's set up on a pine table, but I haven't the patience to block in the initial base layer over such a large area. Is there an easier way for me to block in the base light yellow colour?

A If you want to cover a large area with one base colour, you can use a watercolour pencil in the same shade, then use a large watercolour brush to dissolve the pigment to create a wash and apply it over the area. Alternatively, you can use your favourite oil or wax pencil and dissolve the pigment – apply Zest-it or a solvent such as turps (while wearing protective gloves and in a well-ventilated area) and gently rub the colour over the desired area with a soft cloth or tissue. Whichever method you choose, practise on a spare piece of paper first – the colour cannot be removed, and so mistakes cannot be corrected.

SMOOTH TEXTURES: SHINY FABRICS

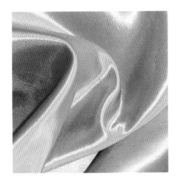

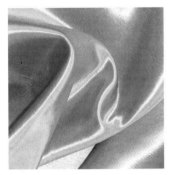

Attempting shiny fabrics like satin can seem quite daunting, but with careful planning, such as which colours to use and where to place them, it can be made a lot easier.

The material used for this demonstration is a lovely copper gold satin. To capture the look and to get the tonal balance right, careful graduation of the seven colours used is essential. The strong highlights must initially be left as the white of the

paper (see Creating Whites, page 26).

It also helps to get the reference photo converted into a good-quality greyscale copy, which can easily be achieved using a photo/graphics package on a computer. By seeing the original reference in tones of grey you can develop the depth of colour in the drawing accordingly. Then, by getting the drawing copied onto a computer and altering that to a greyscale image, the two versions can be compared and the drawing altered if necessary.

Pencils
Prismacolor
Yellow Ochre No. 942
Goldenrod No. 1034
Burnt Ochre No. 943
Sand No. 940
Light Umber No. 941
Dark Brown No. 946
French Grey 70% No. 1074

Paper
Fabriano 5 HP Paper
600gsm (300lb)

Additional equipment
Kneaded putty eraser
Pencil sharpener

1 I started with the mid-tone colour, Yellow Ochre, using it for the outline of the drawing and the initial base layer of colour. Although only one pencil was used at this stage, a variety of pencil pressures were necessary to achieve the gradual change in tone to create the shiny look. Once blocked in, all previously drawn lines, especially those of the highlights, were gently removed using a putty eraser.

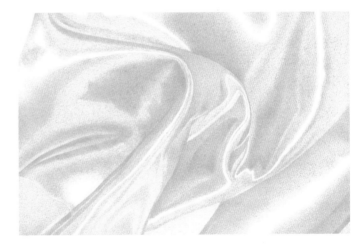

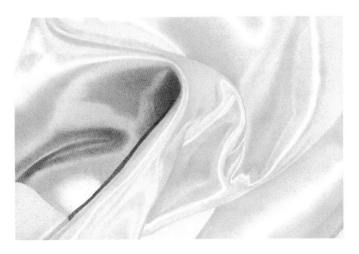

2 Goldenrod was used for the stronger tones, with a *very light layer* of Burnt Ochre blended on top and Goldenrod added upon that. Sand was then used to add colour to the highlight areas, with Goldenrod lightly graduated over the edges of the highlights. I developed the mid-tone areas, alternating between Goldenrod and Yellow Ochre to blend them together. I used Light Umber and then Dark Brown for the dark shadows.

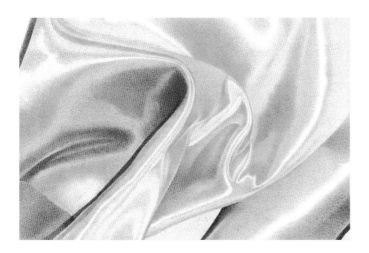

3 I continued to develop the stronger golds and the shadow areas. In the shadows I alternated between Light Umber and Dark Brown to deepen the colour. Burnt Ochre was then added to warm the colour up. In the bottom right-hand corner I used Sand to soften the highlight, Light Umber to darken and Goldenrod to then warm the colour up slightly. In the top left-hand corner of the reference photo the edge of the material can be seen lying upon a white surface, and for this I used a layer of Sand, followed by a soft layer of French Grey 70%.

4 I scanned the picture into my computer and changed the image to a greyscale copy. I then compared the image to that of the greyscale reference photo to check the tonal balance. I decided which areas needed to be deepened and altered the drawing where necessary, reworking the colours previously used.

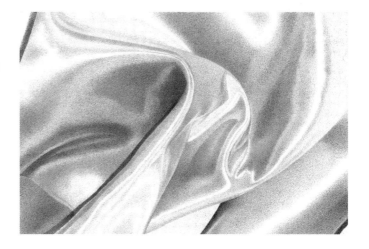

Q I'm about to attempt a piece of shiny fabric for the first time. Being relatively new to coloured pencils, my blending skills still need improving. Is there an easier way for me to distinguish one area of tone from another, so that I know when I need to vary the colour?

A Before starting the fabric, draw all the outlines of the folds and creases out (or copy from your reference photo) on to a piece of tracing paper. Then, taking your chosen colours, add a small swatch of colour to each area, noting at what outline the colour should be faded out or into another colour. The tracing will have the appearance of a painting-by-numbers layout, but when you start colouring in the actual drawing you will know exactly what colour or tone goes where.

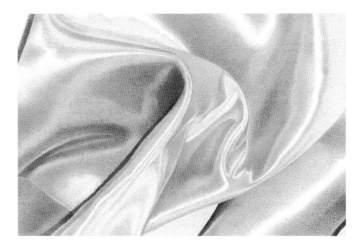

ROUGH TEXTURES: LONG FUR

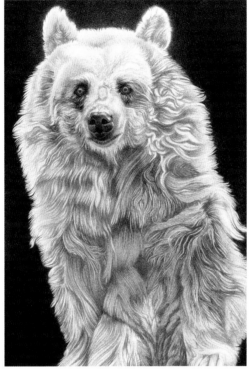

Rough fur is not difficult to achieve, and the method used here can be adapted to suit both medium- and long-haired animals – but it is easier to draw if you have good references to work from. There are a number of things to remember, though, to ensure that it does end up looking realistic and believable.

The skeleton
You don't have to know what the skeleton looks like for the animal you're drawing, but you do have to know that one exists and is the basic framework.

The initial drawing-in of fur over large areas is the most time-consuming part of the drawing, and it can be very tempting to try and hurry the process, but if the lines and shapes of the fur are not drawn

in correctly, the end results will not look right. It's therefore important to take your time and sit back every now and then to check against your reference that the contours of the skeleton are being correctly followed.

Lines and shapes
All fur is made up of individual hairs, but for long-haired animals, it's easier to draw the shapes of large clumps of hair before adding individual hairs. By using tracing paper to copy these shapes and transfer them to your paper, you will save yourself time – in addition, it will help in getting the contours mentioned above in the correct places.

Shades and tones
By following the contours you will see how the fur overlaps itself, creating shadows of various depths. The lightest areas obviously tend to be on the parts nearest to the light source, while the

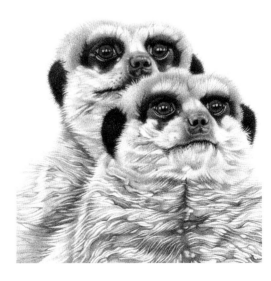

Pencils
Faber-Castell Polychromos
Bistre No. 179
Burnt Sienna No. 283
Black No. 199

Paper
Smooth Cartridge Paper
210gsm (100lb)

Additional equipment
Kneaded putty eraser
Pencil sharpener

darkest areas are furthest away. In between you have the mid-toned areas.

When it comes to blocking in the layers of colour, it is important that these various tones are realistically captured. The colours should be graduated and blended evenly over subtle contours, such as arms and legs, and blocked in more heavily where there are strong shadow areas.

Colour

As always, the light and white areas should be initially reserved as the white of the paper. By using a mid-tone colour for the base drawing, these lights will be left visible, and the darker colours can then be added. Finally, the light areas can be darkened where necessary, leaving the whites showing.

This exercise is based on the dog in Project Eleven (see page 104). If you want to try it and don't have the colours listed, simply pick out a light brown pencil, a golden-coloured pencil and a black pencil.

Dominant shapes drawn in and a few individual lines added

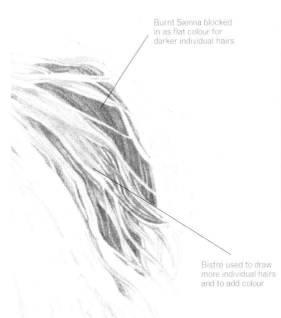

Burnt Sienna blocked in as flat colour for darker individual hairs

Bistre used to draw more individual hairs and to add colour

Tip

When drawing in the initial lines for long fur, make sure they are drawn using one smooth, continuous pencil stroke from top to tip, as broken lines will spoil the look.

1 Using the lightest coloured pencil, Bistre, I drew in shapes for the clumps of hair plus a few individual lines to depict individual hairs. I then blocked in a layer of colour for the darker fur and shadow area, being careful to reserve the white of the paper for the lighter and white hairs.

2 I used Burnt Sienna for the darker fur, blocking in a layer of colour and drawing in some stronger individual lines for the dark hairs. I then used the Bistre to draw in more of the individual hairs and to lightly block in more colour, using various pressures depending on how light or dark the colour needed to be.

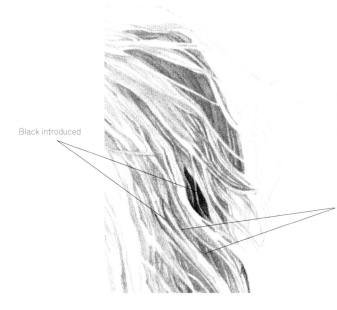

Black introduced

3 Alternating between the Bistre and Burnt Sienna, I continued to develop the dark areas and added more of the lines, being careful to flow and overlap them. I also introduced Black for the darkest hair, blocking in a small area of colour as a clump and drawing in some individual lines.

Alternating lines of Bistre and Burnt Sienna to create greater depth of colour

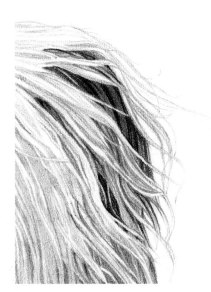

4 I then alternated between the colours to deepen and complete the area. I deepened some of the light areas using the Bistre, and then drew more individual hairs in using all three colours, paying particular attention to creating the very fine hairs along the edge.

Q **I've been asked to draw a portrait of a dog which has a cluster of very wiry white hairs. I've tried reserving the white as you do, but I'm finding it too difficult for so many hairs. Is there another technique I can use?**

A You can use the indentation method, as described in Creating Whites on page 29. Draw the hairs out first on to a piece of tracing paper. Then use a sharp tool to indent each one individually with a smooth, continuous movement, finishing them all before removing the tracing paper. You can then apply your base colour over the indented lines. If you need to add any darker hairs, do this last; so long as the pencil is sharp, you can even add them over the indentations.

ROUGH TEXTURES: SHELLS

When drawing any other rough-textured subjects, such as shells, you need to approach them in exactly the same way as fur, using a combination of individually drawn lines and marks, and blocks of colour. The outline of the shape and all the lines for the individual ridges should be drawn in first, then the colour is added. The three-dimensional shape and form is then developed further by deepening both the colour and shadow areas, adding darker lines and marks.

Illustrated left is a section of an oyster shell. After initially drawing out the shape of the shell, I started to add the colours, using a combination of lines and blocks of colour. To make sure that the colours were kept subtle and light, I blended and layered them together. In some parts four colours were blended together: grey, lilac, pink and blue. The stronger colours, the browns and dark greys, were added later.

To create the three-dimensional characteristic ridges, fine lines were drawn in using a very sharp point. I added a variety of shadow areas to give the ridges even more of a prominent look. Finally, some very small individual black dots were added for the characteristic marks on the shell.

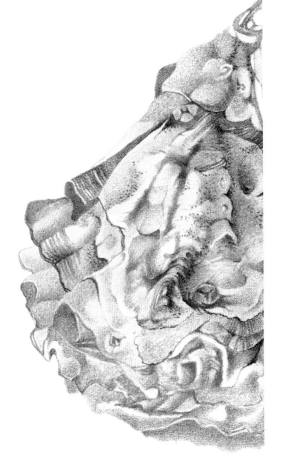

Tip

If you are new to art or coloured pencils and would like to attempt some rough shells, but are worried they may be too complicated, choose ones that have a variety of colour and marks. These are easier to draw than ones that are predominately white or light-coloured.

Q I would really love to draw some shells, but my freehand drawing skills are not yet as good as I would like. Is there an easier way that I can draw them?

A Most shells are small, with nooks and crannies and a variety of tones and shadow areas. Drawing them freehand can be a challenge, and it can be helpful to take photos, you then see them as a two-dimensional object. You can arrange your shells and take the photo as a group, or photograph them individually. Once you have decided on your composition, trace the outlines and main features out on to your paper. Keep the shells in front of you, so that you can capture all the marks and characteristics of each shell.

SOFT TEXTURES

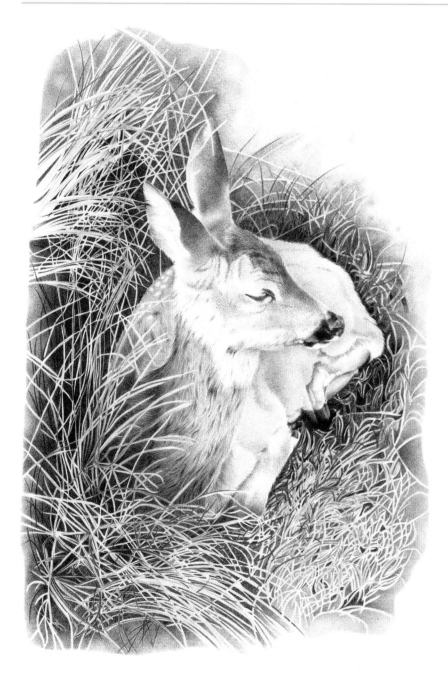

Soft textures can be found on a number of different subjects and objects, including most fabrics – velvets, cottons, muslins, voiles, etc – fruits (nectarines, the insides of bananas, raspberries and other soft fruits that are covered in tiny hairs) and flowers, especially those with velvety textures, such as roses, irises, pansies and sweet peas.

There are many others, including shorthaired animals whose coat has a soft, short appearance (such as cats, horses and deer), backgrounds with soft, muted colours and no exact shapes and form, and foregrounds, for example the overall appearance of a patch of grass.

However, the object you are drawing doesn't have to be totally soft in its composition, and aspects of it might be quite rough, but if the reference you are looking at conveys an overwhelming feeling of softness, then it should be drawn that way, with any rough areas being drawn separately and differently.

Creating textures

Individual blades of grass can be coarse and sharp, capable of cutting fingers, but when seen en masse, as in the drawing left and opposite, grass has an overall appearance of softness, especially as the deer is happily lying down in it. If it were too rough and uncomfortable, the deer wouldn't be sitting there.

To convey this overall feeling of softness, after drawing in the individual blades of grass I blocked in a background

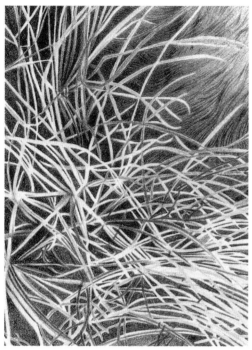

been carefully and softly blended and graduated together, I drew in a few individual, but very short lines to depict this extremely short hair.

On parts of the body where the hair is slightly longer, the base colours were still blended softly together, but with the individual hairs being drawn in longer. When finished, the overall look was one of softness, peacefulness and tranquillity, hence the picture's title, 'Resting'.

colour to soften the appearance and to blend the grass together as one element. In addition, the colours used for the individual blades are soft in colour – pink, blue, yellow and light green. So the overall appearance is one of a soft and inviting patch of grass upon which to sit.

The coat of the deer is completely different in texture to the grass. It, too, is made up of individual hairs, but these are a lot shorter in length and there are a lot more of them, giving the coat an overall appearance of being even softer.

In parts, such as on the side of the body, the hair is almost invisible and the coat is suggested by soft, muted colours subtly blended together. On the bridge of the nose the effect is almost like that of velvet, having the appearance of very short hairs. After the base colours had

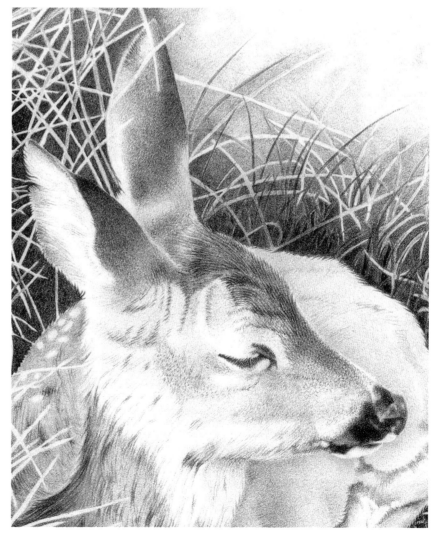

CREATING WHITES

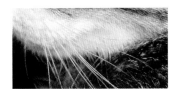

Drawing 'whites' on white paper may seem a daunting prospect, but with careful planning and practice it is very easy. Most subjects that we draw are three-dimensional, not flat, and contain shadow areas. So with careful observation, a spectrum of subtle colours can be seen within these white areas. The important thing to remember is that white is never just white.

The other important point to remember is that if you are drawing on white paper, all the whites must initially be left showing as the paper; they are 'reserved'. I draw all my white areas in using just an outline,

then block my base colour in around them. I then use a variety of colours, such as blues, lilacs, pinks, light yellows/browns and greys, to depict the subtle colours that can be seen in the shadow areas.

With this study of part of a tabby cat, all the white fur was initially left as the paper. The light and mid-tones were then added to create the colours of the lighter fur, and the dark browns and blacks were added at the end. In doing this, the light fur and individual light hairs then stand out against the dark fur. Remember, you are producing an artistic interpretation, not a photo, so you don't have to draw in every single individual hair.

MATERIALS

Pencils
HB pencil
Faber-Castell Polychromos
Black Soft No. 99
Cold Grey III No. 232
Raw Umber No. 180
Burnt Ochre No. 187
Cold Grey IV No. 233
Light Magenta No. 119
Light Ultramarine No. 140
Burnt Umber No. 280

Paper
Smooth Cartridge Paper
210gsm (100lb)

Additional equipment
Tracing paper
Kneaded putty eraser
Pencil sharpener

1 For this demonstration of the mouth and chin of the cat, I drew the image on to tracing paper using an HB pencil and transferred it on to the paper. I then used a putty eraser to gently lift the majority of the pencil marks off, leaving just a subtle outline showing; this way, the paper was kept as clean and white as possible.

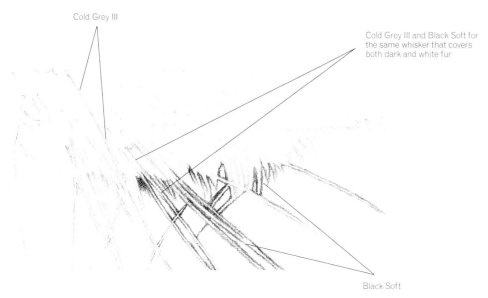

Cold Grey III

Cold Grey III and Black Soft for
the same whisker that covers
both dark and white fur

Black Soft

2 Having decided where the whiskers were going
to go, I drew them out as single lines. I used a
Black Soft pencil for the whiskers that go across
the dark fur, and Cold Grey III for the whiskers
that go over the white fur. I alternated between these
colours for the whiskers that covered both the dark and
white fur.

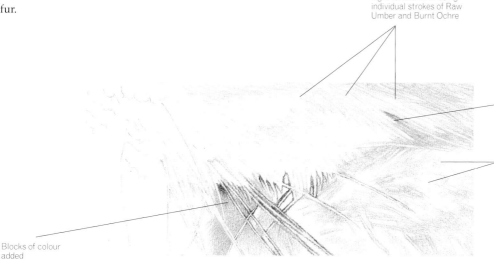

Light fur drawn in using
individual strokes of Raw
Umber and Burnt Ochre

Cold Grey IV used for
darker individual lines

Individual white
hairs now become
more prominent

Blocks of colour
added

3 I now started to block in the fur surrounding the whiskers.
Because the cat is a tabby, I blocked in the lightest colours
first, using individual strokes to depict and define the
individual hairs that fall over and upon the white fur, and
used blocks of colour for where the fur was going to be more solid.
For this I alternated between Raw Umber, Burnt Ochre, Cold Grey
III and Cold Grey IV. I drew individual white hairs as outlines,
leaving the white paper showing. In doing this, the white hairs
that had been previously left now became more prominent.

Tip
When drawing individual
strokes to depict fur, it's
helpful to turn the picture
around and work on it at
different angles. This
makes drawing in the
strokes easier, as the
pencil can flow freely and
in the same direction as
the contours of the
animal's face and body.

27

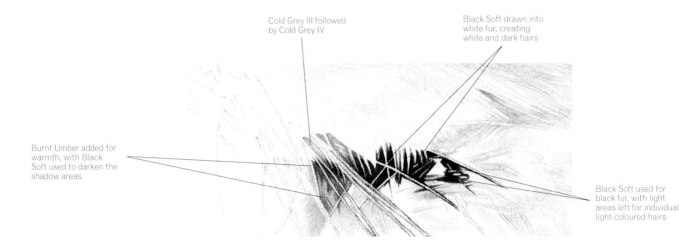

Cold Grey III followed
by Cold Grey IV

Black Soft drawn into
white fur, creating
white and dark hairs

Burnt Umber added for
warmth, with Black
Soft used to darken the
shadow areas

Black Soft used for
black fur, with light
areas left for individual
light-coloured hairs

Tip

Black Soft is so soft it
can leave behind small
amounts of pigment dust,
which, if touched, can
smudge. To prevent this,
brush the area very lightly
with a clean, dry
watercolour brush, and
cover the work with a
spare piece of paper so
the colour won't smudge.

4 I now started to block in the black fur, stroking it into the white areas to create soft edges and individual dark and white hairs. It's important to keep the pencil sharp at this stage so that all whiskers and hairs are given sharp edges. Cold Grey III was used on the edges of the white fur to soften it still further, and Cold Grey IV to deepen the colour in the shadow areas. Burnt Umber was then used to add some warmth, followed by Black Soft, both delicately blended into the Raw Umber areas.

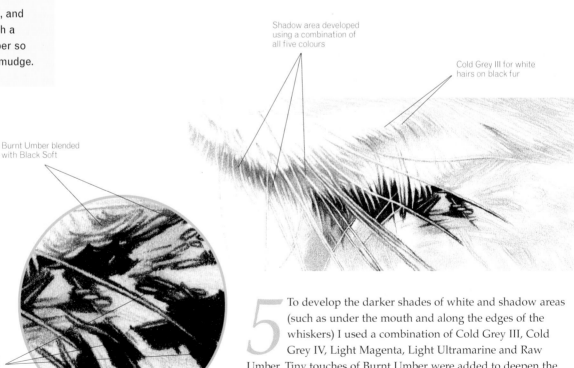

Shadow area developed
using a combination of
all five colours

Cold Grey III for white
hairs on black fur

Burnt Umber blended
with Black Soft

Black fur blocked in,
leaving base colours
showing through as
individual hairs

5 To develop the darker shades of white and shadow areas (such as under the mouth and along the edges of the whiskers) I used a combination of Cold Grey III, Cold Grey IV, Light Magenta, Light Ultramarine and Raw Umber. Tiny touches of Burnt Umber were added to deepen the shadow areas, followed by Cold Grey IV. For the individual white hairs on the white fur, I used soft individual strokes of Cold Grey III. I continued to work on the black fur using Black Soft, leaving more individual light-coloured hairs showing. Burnt Umber was blended with Black Soft to create a soft edge to the white fur.

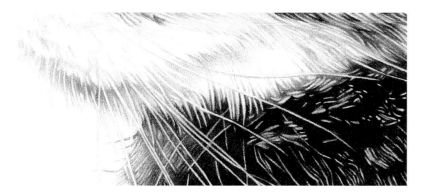

6 I now blocked in the rest of the fur. For the face, I used a combination of Raw Umber, Burnt Umber, Cold Grey III and Burnt Ochre, applied in strokes, with touches of Black Soft applied to the darker areas. Below the chin line I used blocks of Burnt Umber and Black Soft, alternated with individual strokes, so that the base colours of Burnt Ochre and Raw Umber were able to show through as individual hairs. Once all the black was blocked in, I toned down some of the individual hairs using touches of Raw Umber and Cold Grey III.

Q I've forgotten to leave the white paper showing for the whiskers. Are there any other ways I can draw them in?

A There are other ways that white whiskers can be drawn in, as described below.

Indentation

To indent a 'white' line into your paper, take a piece of tracing paper (preferably with the lines predrawn as a guide), then, using a sharp instrument, such as a knitting needle or hard pencil, redraw the lines. Take a medium-to dark pencil and lightly colour in over the top. The pencil skids over the surface, catching the paper on either side and leaving the indentation showing white. However, for white lines and marks the indents have to be made before progressing with the drawing, so you can't add them later unless you want the indent to be a colour. Indents also cause damage to the fibres of the paper, and once an indent has been made, you cannot remove the line.

Sgraffito (scratching)

Carefully using a scalpel or craft knife, you can scratch away previously applied pencil pigment to reveal the white paper underneath. This works best on smooth paper. However, scratching away the pencil can damage the fibres of the paper, and the line can appear 'feathery'. You may need to go over the initial scratch to increase the thickness, but this can result in an unnatural look, with the whisker appearing thicker in the middle.

Painting

You can add watercolour or gouache paint at the final stage, using a very fine watercolour brush. The consistency of the paint, however, needs to be just right, to allow one sweeping brushstroke. As the paint dries, it can become less opaque, drying grey as opposed to white. You may then need to go back over the initial brushstroke – and a steady hand is a must, otherwise the paint may blob, giving the whisker an unnatural and uneven look.

THE COLOURS OF WHITE

The photos here are all taken from the same part of a white shirt, but each one is taken with a different light source and overemphasizes the colours that can be seen in white, to help you get a better understanding of how the colours of white really do vary.

The important thing to remember when attempting to reproduce a white object is to pick your colours carefully and pay particular attention to the colours in the shadow areas. Then try them out in various combinations on a spare piece of paper until you get the colours right.

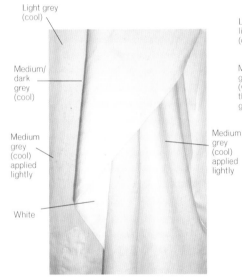

Light grey (cool)

Medium/dark grey (cool)

Medium grey (cool) applied lightly

White

Medium grey (cool) applied lightly

Lilac on light grey (cool)

Medium grey (warm) then dark grey (cool)

Ochre/yellow

Medium grey (cool)

Ochre/yellow on light grey (cool) and lilac/violet

Ochre/yellow

Light blue on grey

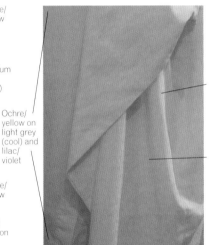

Ochre/yellow

Medium grey (cool)

Initially left white and light grey added later

Medium grey (cool) on ochre

Cool Here, the overall colour is basically a cool light grey. To draw this, block in a very light layer using a cool light grey pencil before adding any other shade of grey. One of the inner folds is almost white compared to the rest of the photo, so reserve this area as the white of the paper until the rest of the colour is blocked.

Tone it down as necessary, and assess the depth of colour needed by comparing it to the colour laid down around it. For the mid-toned shadow areas in the creases, use a cool medium grey, applying it with varying pressure and graduating the colour away.

For the stronger shadow areas along the outer edges of the folds, use a combination of cool medium grey and cool dark grey, graduating the colour over the edges to soften them and to create the three-dimensional look.

Warm This picture is slightly warmer in tone, and has a lilac/blue tint to the overall colour. Initially block in a very light layer of cool light grey, then add a layer using a combination of lilac/violet and a light sky blue.

To capture the very subtle areas of yellow, which reflect the light, add a very light layer of either yellow ochre or pale yellow, depending on how strong the colour needs to be. For the strong shadow areas along the folds, use a base layer of lightly applied warm medium grey, followed by a cool dark grey.

Continue to alternate between a combination of cool light grey and lilac until the right depth of body colour has been achieved, possibly even adding a very light layer of a warm light grey.

Extreme This photo was taken under a strong yellow light. Other than the highlights that can be seen on the right-hand side of the folds, the entire picture is covered in an ochre/yellow tint.

Initially reserve the highlights as the white of the paper, and then start by blocking in the base colour. Using a combination of cool light grey, lilac and ochre, alternate between the three colours, starting with a base layer of cool light grey, followed by a light layer of lilac, then ochre and cool light grey, until the depth of colour required is achieved.

For the light shadow areas, use a cool medium grey, and for the darker shadows, a cool dark grey. Finally, tone the highlights down using the cool light grey.

HIGHLIGHTS: EYES

There's no doubt that drawing realistic eyes can be a challenge, but liquid, glassy and three-dimensional eyes can be achieved quite easily.

There are two important points to remember here. First, the pencils should always be applied *very lightly* and in alternating layers, keeping the colours fresh and transparent. You can always deepen the colours at a later stage, but they can be difficult to remove. If yellow is applied too thickly too much base compound of oil/wax is applied, and other colours won't blend well over it.

Second, it's important to get the highlights right and in the correct position. A common mistake made by beginners is to copy the photo reference literally – if the photo was taken using a flash, the subject may have red-eye, which is not a natural look.

It's also important to remember that highlights are reflections of the surrounding environment, and you should try to capture these for a realistic look.

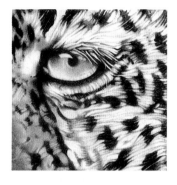

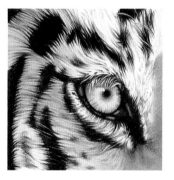

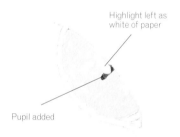

Highlight left as white of paper

Pupil added

1 I traced out the eye, including an outline for the highlight, using an HB pencil. I then gently dabbed at the pencil to remove most of the pencil marks, so as not to dirty the yellow base layer. I then added a *very soft, light* layer of Deep Cadmium Yellow and blocked in the pupil using Ivory Black, leaving the highlight as the white of the paper.

2 After the Deep Cadmium Yellow, a *very soft, light* layer of Olive Green was then added, leaving a line of yellow showing along the bottom eyelid. The colour was applied heavier around the bottom of the pupil and just above the lower eyelid. The distinguishing dark marks were also added at this stage. The eye was now beginning to look realistic and rounded in shape.

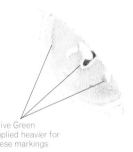

Olive Green applied heavier for these markings

Orange Chrome followed by Brown Ochre

3 A *very soft* layer of Orange Chrome was used to give the eye colour some warmth. This was applied over the previous layer of Olive Green and along the lower eyelid line. Brown Ochre was then lightly added on top of the Orange Chrome to soften the overall effect.

Brown Ochre added before Ivory Black to warm up black

4 It's not just the eye that has highlights – the outer edges of the eyelids also have them. Ivory Black was used on these, but on the outside, where the light falls, a *light* layer of Brown Ochre was added first to warm up the black. Although initially left white, the highlight was toned down using a *very soft* layer of Ivory Black. Some black fur was also drawn in, as it helps to get the tonal balance of the eye colouring right. I could now see that the colour of the eye was too light and appeared to be receding, and I was now able to judge how much the colour needed to be deepened.

5 The whole eye was now darkened, and the highlight on the pupil was blocked in using a *very soft* layer of Ivory Black. Brown Ochre was added along the inside of the bottom lid and around the pupil, and I applied a layer of Deep Cadmium Yellow over the entire surface of the eye, applying more pressure where it fell upon the previously applied green, but leaving a line of light showing along the bottom. Olive Green was now used to draw in the outline of the soft highlights. By drawing in the shapes that could be seen, then colouring around them, the yellow showed through as soft highlights. I then used Brown Ochre and Orange Chrome to deepen the colour around the eyelid.

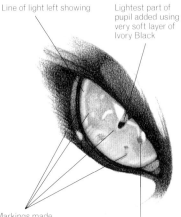

Line of light left showing

Lightest part of pupil added using very soft layer of Ivory Black

Markings made more dominant all over

Soft highlights drawn in using Olive Green

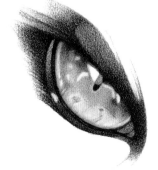

6 Finally, I added some shadow to the top and left-hand side of the eye, using a *very soft* layer of Ivory Black followed by Olive Green, and I toned down the small highlights by adding a *very soft* touch of Deep Cadmium Yellow followed by Olive Green. Ivory Black was used to strengthen some of the marks in the eye. On the bottom of the eye I added Deep Cadmium Yellow, Orange Chrome and Brown Ochre, followed by Olive Green.

Tip
Eyes without highlights appear flat, dull and lifeless. If you are drawing an animal and its eyes don't contain any highlights, seek out additional reference material of the same breed showing an eye, but with a highlight. You can then add a similar highlight to your drawing. I did this for the eagle owl on page 74.

Q I've forgotten to put in a highlight and have already blocked in my base colour. Is there any way I can add the highlight now?

A It is possible to remove some of the pencil and draw in the highlight. An electric eraser is good for this, because it is powerful enough to remove the pigment while being carefully controlled. Otherwise, dab at the area with a putty eraser kneaded to a point – but with each tool, practise beforehand on a piece of scrap paper.

HIGHLIGHTS: GLASS

All glass objects, whether flat, such as a window, or round, such as a glass or bottle, should have highlights to convey the fact that they are solid, hard and shiny objects that reflect light.

Adding highlights around the contours of a round object also helps to create a more realistic three-dimensional shape – it's important to observe glass closely when drawing it, as the highlights will vary in tone. The strongest highlights are reflections of the brightest light source, which may be artificial, such as a light, or natural, such as sunlight streaming through a window, and generally are reserved as the white of the paper. As the light diffuses around the sides of a bottle or glass, the highlight becomes more subtle.

Because bottles, glasses and glass vases are round in shape, try to draw every angle that can be seen, from the front right through to the back. Getting the shape of the object right is equally important to getting the look of glass, and both aspects can be difficult to achieve.

Drawing glass

The best exercise is to practise drawing from still life, with the glass or bottle in front of you. If you have never drawn glass before, you may find it easier to draw a coloured bottle, such as green, blue or brown. That way, you can pick the shades of colour to suit, and not worry too much about getting the tones and colours of white and grey right that would be necessary in drawing a clear bottle; the method for drawing a clear bottle is the same as that for drawing a white object, looking for subtle colours that are reflected off the surface and in the shadow areas, and using a range of greys.

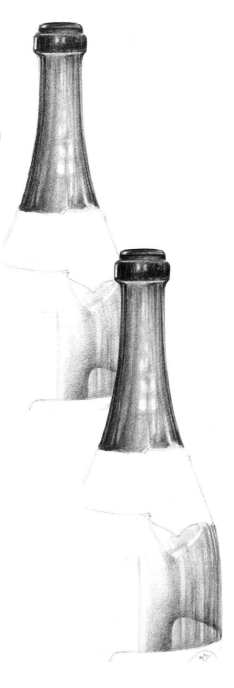

The drawing here is part of a green wine bottle, which I have also converted to greyscale to illustrate the range of greys that could be used if drawing a clear bottle. After initially sketching the outline out I started to block the colour in, aiming to capture both the transparent look of solid glass and the highlights.

Because it is more of a sketch then a tightly drawn, finished piece, I could correct the bottle's round shape as the drawing progressed. This way, I did not become too obsessed with just one aspect, and could improve the drawing where necessary.

The pencils were applied using mainly vertical lines with added soft blocks of colour, and I alternated between different shades to create both the round shape and the transparent look. The darker colours were at the top of the bottle around the opening, where the glass was thicker and less light was able to pass through, and on the sides.

Part of the wine label was also added, and it can be seen wrapped around the bottle. The colours used to suggest the opacity of the white of the back of the label also helped to create a three-dimensional look.

The main highlight shown is of a window and is quite subtle, being drawn with soft, as opposed to hard, edges. The softer highlights were created by alternating between light and dark shades.

PLANNING AND COMPOSITION

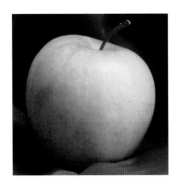

The projects in this book cover different aspects of planning and composition, depending on the individual subject matter, but there are certain things that can be applied to all pictures. Any picture can be greatly improved with a little forward planning, so it's well worth spending time before you start on getting everything right, including the correct reference material and the right format and composition.

Before starting any new picture, although I often know exactly what it is I want to draw, I still have to find the right reference material. If it's a still life of shells I will collect as many as possible and lay them out on my table, arranging, then rearranging them until I have a composition I'm happy with. If it's a portrait of an animal I will visit safari parks and private collections, taking at least 40 photos of an individual animal in the hope of getting at least five that are worth using (sometimes combining photos together to get one picture). I also keep a camera loaded and nearby at all times for when one of my cats gets into an interesting position!

Although I was keen to leave my graphics job because of the introduction of the computer into the workplace, I now use it nearly every day for my own work, especially for storing my reference photos and for planning my composition. If you don't own a computer, there are a number of tools easily available that can be used when planning a new picture.

Reference material

Before starting any new picture, even if I know what it's going to be, I have to find my reference material, and this usually involves taking photos.

All artists, whether amateur or professional, should use their own original reference photos (or those of family and friends with their permission), and not those published in books or magazines. There are two main reasons for this: legal (copyright laws) and personal (for your own artistic merit and development).

Copyright laws

The law in the UK is very straightforward when it comes to the copying of others' work – it's not allowed. An artist or photographer automatically owns all copyright on original pieces created, and so if somebody copies work without their permission, he or she would be breaking the law and could be prosecuted.

There's nothing wrong in taking inspiration from another artist's work, and most photographers and artists understand that an amateur artist may copy one of their pieces for their own personal use, but you really should use your own reference, especially if you are looking to sell your work. If you do see a photo you really like and would like to copy it, then contact the photographer or agent, as they may grant you permission to use it.

Occasionally, I refer to professional photos to check on the details of certain subjects, especially when drawing

wildlife, as my own reference photos are occasionally lacking in detail. If I need clarification on something, such as what the nose of a meerkat looks like, I will refer to a wildlife book – but I always use my own photos for the actual composition of the drawing.

Personal development

As an artist, if you copy another's work, you are not creating a unique or personal picture that reflects your own personality or creativity. Also, there may be something wrong in somebody else's photo that, if copied exactly, makes your own picture look wrong. If you had taken the photo you would have been more aware of these mistakes. Unless you spend time observing your reference closely and in person, you never truly gain an understanding of the subject.

That's why, to grow as an artist and to develop your artistic skills, it's important to find your own reference material, whether that means taking hundreds of photos or setting up a still life on your kitchen table. You will learn so much more about your subject, about its shape, form, the different textures and colours, how the light falls upon it and the overall composition. All this will improve your drawing skills, thereby making for a better picture, and will make the end results even more rewarding.

Reference photos

Because artists are often limited for both time and space, photos are a wonderful

tool. Although there is no substitute for drawing from life, occasionally you may need to leave a picture and return to it at a later date. By making a permanent record of your subject, you can return and resume where you left off.

Even when I set up a still life I take numerous photos. That way I don't have to worry if it gets disturbed, and, more importantly, if the light changes over the course of a day, I have a permanent record of when the light was at its best. For a still life that contains real fruit or flowers it is also especially helpful, as a flower has often long wilted before I've had time to complete it, or a piece of fruit has wrinkled and withered. In addition to the overall composition, I take close-up shots of individual elements, so I have records of the finer, small details.

I use an automatic single lens reflex (SLR) 35mm zoom camera. I also have a digital camera for occasional use, but I prefer to use the SLR camera for reference photos, as it gives me sharper images. Once I've had the film developed I pick out my favourite shots and scan them into my computer. I then enlarge and crop them into various sizes until I get a composition I'm happy with, printing the final one out to use.

If you haven't got a computer it's easy and inexpensive to get colour photocopies of your photos done – look in your local telephone directory for Colour Photocopy/Reproduction shops. Before you visit, have a good idea of what finished size and composition you want, as the

Note

The projects in this book contain photos that were taken by me. You have my permission to use them for your own personal use and development. You may exhibit or show the end results, but not reproduce them for financial gain.

If you do find some of the projects of particular interest, why not take your own photos of the same subject and use them in a picture of your own?

shop will be able to enlarge and crop them as requested. Alternatively, try your local library – public libraries often have colour photocopiers for the public to use, and some even have scanners and computers or lists of local community computer centres where the public can be shown how to use computers and scanners.

Composition

Composition is very important, because even the best-drawn picture can look wrong if incorrectly positioned on the paper. The best compositions take our eyes into the frame, lead our eyes around the picture and keep us in the space.

Positioning

There are some simple rules to follow when positioning objects. When working on a single, vertical-shaped object, position the paper in a portrait shape. If the object is horizontal, use a landscape position.

Place vertical-shaped objects on a portrait or square piece of paper.

When placing the object there should be slightly more space at the bottom than at the top as above, otherwise the object will appear to be falling off the edge of the paper (below right).

The best way to check whether an object is correctly placed is to look at it behind various sizes and shapes of picture mounts. Never force a picture to fit inside a ready-made frame – this is a false economy that can spoil the finished piece.

Project One

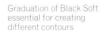
Graduation of Black Soft
essential for creating
different contours

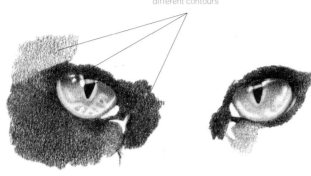

5 I next decided to draw and block in a small rectangular area of fur around the eyes to create a small, but finished picture. To create the contours of the eye sockets, bridge of the nose and cheekbones, it was important that the pencil was graduated to create the variation in tone. For the darker areas, the Black Soft was applied with more pressure.

Bridge of nose developed

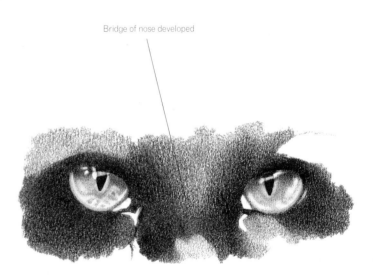

6 The rounded shape of the bridge of the nose was developed further, making the eyes appear more prominent within their sockets. The Black Soft was continued further down the nose.

Olive Green Yellowish

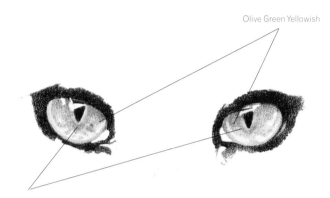

Brown Ochre

3 The eyes were now at a stage where the colours needed to be deepened further and given a more rounded and glassy look. I added another *very light* layer of Lemon Cadmium to the upper part of the eyes. This warmed the eye colour up even further, but left the lower part of the eye cool. This helped to create more of a three-dimensional look. I then used Olive Green Yellowish at the top of the eyes to deepen the eye colours still further, then added a *light* touch of Dark Chrome Yellow over the Brown Ochre to brighten up the overall colour. I then deepened the strong markings still further, using Brown Ochre.

Highlights on pupils given soft layer of Black Soft

Shadow areas added using Black Soft

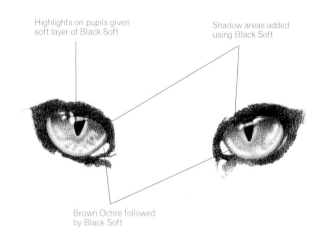

Brown Ochre followed by Black Soft

4 I added the shadow area at the tops of the eyes, helping to define their shapes still further and to bring out the highlights using a *very, very light* layer of Black Soft. I redefined the pupils' general shape and deepened the colour. The highlights that fall upon the pupil were given a soft layer of Black Soft. The inner part of the eye colour was strengthened using Brown Ochre followed by a few further touches of Black Soft.

Project One

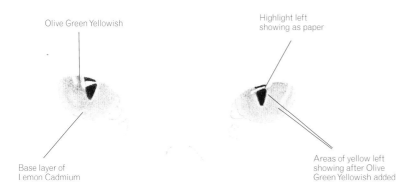

Olive Green Yellowish

Highlight left showing as paper

Base layer of Lemon Cadmium

Areas of yellow left showing after Olive Green Yellowish added

1 After initially tracing the image out on to my paper using an HB pencil, I drew in the pupils using Black Soft. I then applied Lemon Cadmium as a *very light* base layer, making sure that I left the highlights showing as the white of the paper. I then added a soft layer of Olive Green Yellowish to the upper part of the eyes, leaving a line of yellow showing around the pupil and along the lower bottom eyelids, and added the distinguishing marks that could be seen within the iris of both the eyes with the resharpened Olive Green Yellowish.

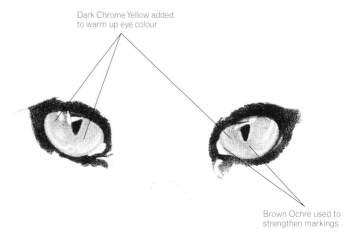

Dark Chrome Yellow added to warm up eye colour

Brown Ochre used to strengthen markings

2 Getting the depth of colour right can be quite difficult. It's always best to apply the colours lightly first, otherwise if too much yellow is applied the paper surface can become waxy or oily, making it difficult to add more colours. To help judge the depth of colour and to start getting the tone right at this stage, I started to draw in the eye socket, lid and fur around each eye using Black Soft. I then added a layer of Dark Chrome Yellow to add warmth to the eyes, and Brown Ochre to strengthen the markings.

Tip

The better the reference you work from, the better the drawing will be. This applies to all subject matter, but none more so than reference for eyes. All cats' eyes are wonderful and interesting to draw, but I try to pick the eyes that contain a combination of strong highlights, a variety of colours and markings, and a good contrast in the light and shadow areas.

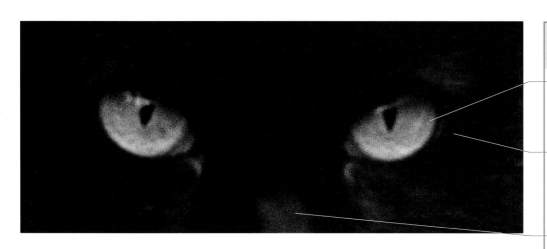

Notes to remember

Reserve the white of the paper for the
highlights. It's far better to make the
highlights bigger at the beginning than it
is to try and remove colour for them at
the final stages.

Keep the pencil layers soft, so that the
eyes look translucent and liquid. Very
often, people new to coloured pencils
tend to apply the pencils too thickly too
soon, creating a solid but flat colour. Even
if the initial layer of yellow appears almost
too light to see, don't be tempted to
deepen the colour – it is there, and you
can always add another layer at a later
stage if necessary. Use a sharp pencil for
the fine markings in the eye. If the pencil
is too blunt, the markings will not be
sufficiently distinguishable from the rest
of the colour to stand out.

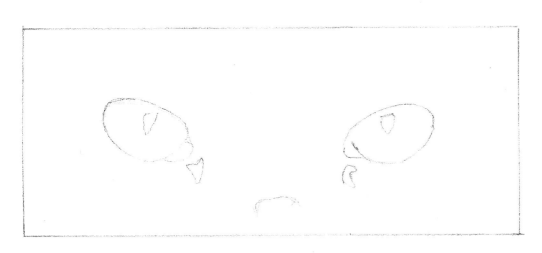

PROJECT ONE: CAT'S EYES

MATERIALS
Pencils
HB pencil
Faber-Castell Polychromos

Black Soft No. 99

Lemon Cadmium No. 105

Olive Green Yellowish No. 173

Dark Chrome Yellow No. 109

Brown Ochre No. 182

Paper
Smooth Cartridge Paper
210gsm (100lb)
Tracing paper

Additional equipment
Kneaded putty eraser
Pencil sharpener
Fixative

Aims To draw a cat's eyes, using subtle colouring and a light touch. The layers of colour must remain almost transparent, so that each colour can shine through.

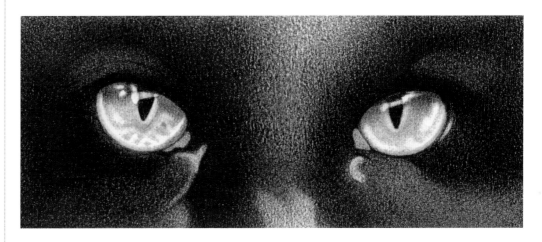

Finished size of my drawing: 3.5 x 8.3cm (1³/₈ x 3¹/₄in)

There are a number of things you can do to help get the composition right. If taking photos, make use of the viewfinder. Take your time and turn the camera around to see if the composition works better as a landscape or portrait format. Take loads of photos so you can compare them once the films been developed.

I did exactly that with Project Ten (see page 94). Shown right is a selection of photos, with a commentary about what is good or bad about each composition, and why I decided on one particular photo. I had already decided on the title, Apple Green and Pinks, and knew that the apple and pink materials were of equal importance, so they needed to be allowed an equal amount of space within the picture frame.

Grouping objects

Sometimes it is necessary to take a number of individual photos and group them together to create one composition. Get colour copies made, enlarge them to the actual size you want them, and arrange them on a flat surface until you're happy with the composition. Then use tracing paper to copy the images out as one complete piece.

Whichever way you prefer to compose and plan your work, a little time taken with each of these stages will help you to achieve the best results.

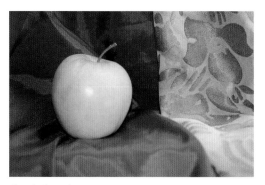

Apple too close
In this photo the apple is too close to the patterned material. There isn't enough space between the three elements (the apple and two pieces of material), and the apple dominates the space.

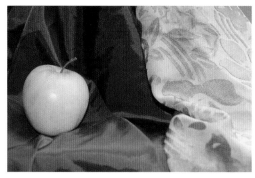

Colours and tone too flat
This photo was taken with a flash that caused all the colour to drain out, leaving the colours dull. This also caused problems with the tone. Basically, there is not enough variety and depth in the tonal range, causing the photo to appear flat.

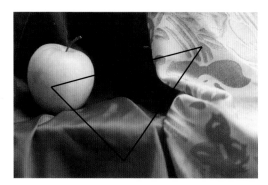

Colours
The layout in this photo is just right for the drawing I had in mind. All three elements appear equal and visually create the points of a triangle, helping to fill the space comfortably.

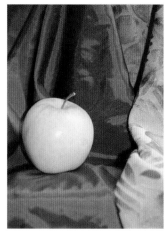

Layout and proportion wrong
This photo was taken in portrait format. Unfortunately, there is not enough material showing around the apple, and it looks as though it is being squashed in the frame. Again, the apple appears to be dominating the space.

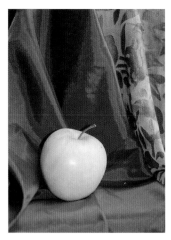

Not enough patterned material
There is not enough patterned material on the right-hand side; ideally, the materials should be equal in size.

Eyebrows defined using
light layers of Black Soft

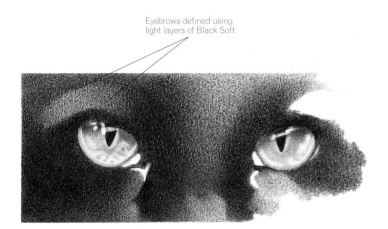

7 I started to extend the Black Soft to the edges of the
rectangle, going back over the areas previously blocked
in stage 6, which gives a smoother look to the fur. To
define the area of the eyebrows, the Black Soft was
applied lighter.

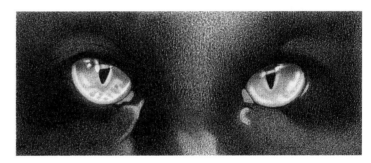

8 I finished off the drawing by completing the fur and
deepening the colours where necessary, such as around
the sockets and the shadow areas. I also added a *very* soft
layer of Black Soft to the inner corners of the eyes. Finally
I fixed the drawing to prevent the black from smudging.

**Q I've been asked to draw a portrait of a friend's
cat, but the photo she prefers, although the cat
is in a lovely pose, has the eyes wide open, with
extremely large pupils and very little colour. I'm
worried that the end result will end up with the eyes
looking like big black holes. What can I do to
prevent this happening?**

A The reason why the pupils are wide open is because
the photo was taken in very little light, and the cat's
pupils opened to take in as much light as possible. There
should still be highlights across the pupil, even if from an
artificial source such as overhead light. By ensuring that
a highlight is added and applying another colour very softly
around the highlight, such as grey, blue or brown, you will
create softness. This in turn helps to create the curve of the
eye. The black should be used heavier at the bottom of the
pupil, and graduated softly towards the highlight and over
the previously added colours.

PROJECT TWO: STUDY OF A FEATHER

MATERIALS
Pencils
HB pencil
Faber-Castell Polychromos

Light Sepia No. 177

Nougat No. 178

Dark Sepia No. 175

Cold Grey I No. 230

Cold Grey IV No. 233

Cold Grey III No. 232

Dark Naples Ochre No. 184

Paper
Canson Smooth Bristol
Paper 210gsm (100lb)
Tracing paper

Additional equipment
As for Project One

Aims To capture the delicacy of a feather's texture, colour and form. A feather such as the one used here, that of a buzzard, is interesting, even though it appears predominately to be just one colour.

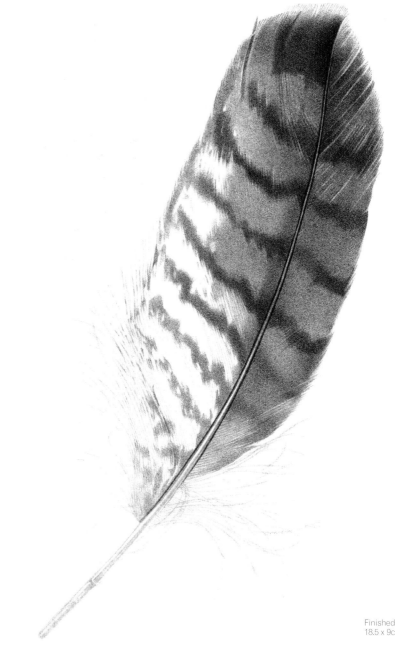

Finished size of my drawing:
18.5 x 9cm (7¼ x 3½in)

Notes to remember

Try not to draw in every single one of the individual hairs (fronds) that make up one complete feather. It is the overall look and fluffiness that is interesting, not an exact scientific copy. I used a combination of blending and graduating blocks of colour to suggest the softness, followed by the drawing in of some of the very fine lines to give the feather its overall feather-like look – it is particularly important to add the fine lines around the feather's outline, as they are the ones that we see when holding a feather. I kept my pencil sharpened at all times.

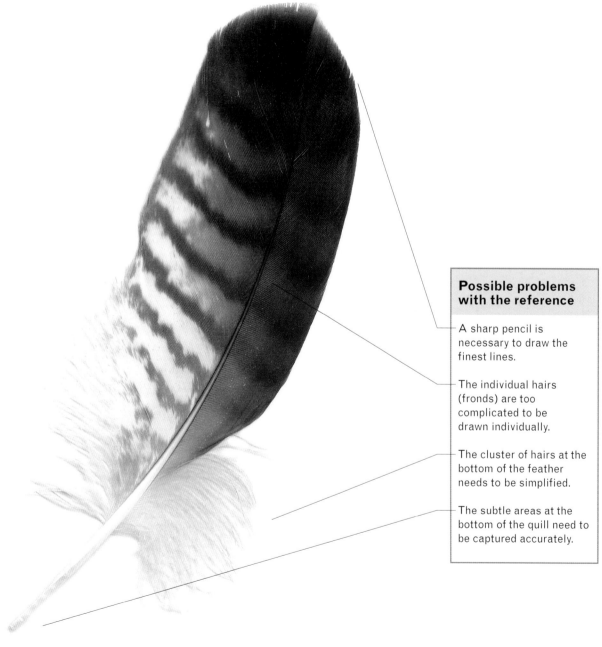

Possible problems with the reference

A sharp pencil is necessary to draw the finest lines.

The individual hairs (fronds) are too complicated to be drawn individually.

The cluster of hairs at the bottom of the feather needs to be simplified.

The subtle areas at the bottom of the quill need to be captured accurately.

Project Two

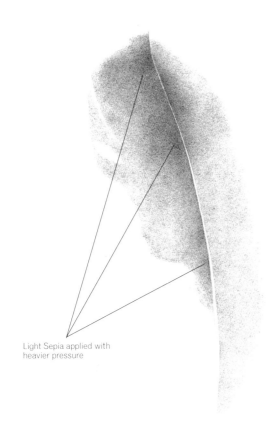

Light Sepia applied with
heavier pressure

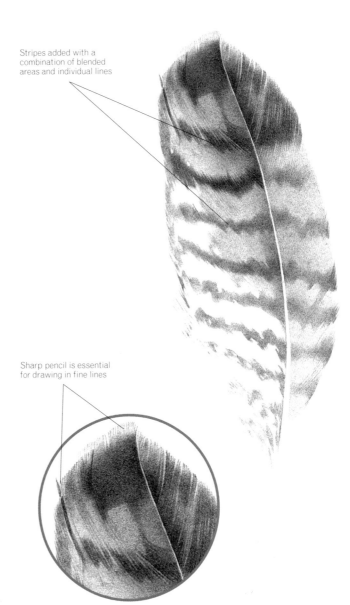

Stripes added with a
combination of blended
areas and individual lines

Sharp pencil is essential
for drawing in fine lines

1 I started by sketching out the basic shape of the feather
and then blocked in a base layer of Light Sepia,
concentrating on the overall colour and not worrying
about the striped markings. I graduated the pencil to
create the differing dark and light areas, and left the centre part
of the feather, the quill, showing as the white of the paper at
this stage.

2 Once I had the shape roughly defined, I started to add
the stronger markings and feathered edge with Light
Sepia. For the stripes I reapplied the pencil with more
pressure. For the feathered edges and the individual lines
depicting the hairs, I used a combination of lines and blending to
create the feathered look. I kept my pencil sharpened to give the
lines a crisp look.

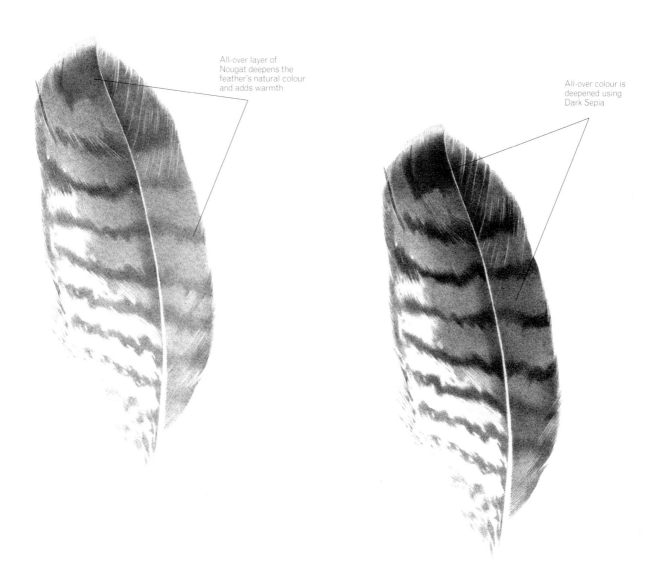

All-over layer of
Nougat deepens the
feather's natural colour
and adds warmth

All-over colour is
deepened using
Dark Sepia

3 Once the base colour and markings had been blocked in
I added a layer of Nougat to develop the feather's natural
colour and to add warmth.

4 To deepen the overall colour, I went over the top half of
the feather and the right-hand side using Dark Sepia,
applying the pencil again as a block of colour, blending
and graduating it into the base layer of Light Sepia and
Nougat, being careful not to cover the previously drawn fine
lines. I applied more pressure to the striped markings to deepen
their colour. The bottom left-hand markings were deepened
using Nougat.

Project Two

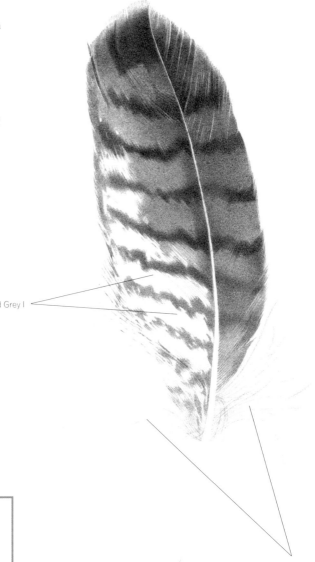

5 Once I was happy with the overall colouring I started on the fine details, such as the very fine fluffy lines at the bottom and on the left-hand side. Artistic licence was called for with regards to both their look and colour – I used a combination of Nougat and Cold Grey IV, tinting the fine individual lines *very lightly*. Along the left-hand side, where the feather appears to be a solid area of white, I added a soft layer of Cold Grey I to define the edge of the feather before it becomes individual hairs. *Sharp pencils are essential here*.

Cold Grey I

Individual lines drawn in using sharp pencil

Q **I want to draw a feather that is mainly white, especially around the edges. Should I just draw in the outline and leave it like that?**

A It's very tempting to leave outlines of objects drawn in using, say, an HB pencil, but it's better to add some colour. Refer to 'The Colours of White' on page 30 for more advice on how to colour in white.

Alternatively, you can add a very light shadow around the edges. By placing the white feather on to a piece of white paper, you will be able to see where the shadows fall and what colour they should be.

6 I next coloured in the quill, which appeared white and yet transparent at the bottom. For the white area I used Cold Grey III, followed by a *light* touch of Dark Naples Ochre at the very tip. On the upper part of the quill I used Nougat, followed by Light Sepia. I then used Dark Sepia for the stronger shadows along the edges of the quill. Finally, I deepened some of the fine fluffy lines using Cold Grey IV. For this drawing I decided not to put in a shadow because I wanted the fine-feathered edges to stand out. Once fixed, mounted and framed, it looked like a feather caught as it fell to the ground.

Tip

Practise drawing fine lines on a separate piece of paper, and try to create a pattern from which you can work for the actual drawing. To help, place the feather on a piece of white paper. You will then be able to visibly see the fine lines. You can also see the colours more clearly, as no two whites laid side by side are the same. It also sometimes helps to turn the picture around, so that your hand flows easily in the direction of the line you are attempting to draw.

When drawing a selection of free-flowing lines such as these, there is a tendency to become too mechanical, especially when you try to rush them, or if you begin to find the pattern too complex. This, however, will only make the drawing too regimented and artificial-looking. For a more realistic look, allow the lines to flow over each other, and try not to rush.

PROJECT THREE: SPRING FLOWERS

MATERIALS
Pencils
HB pencil
Faber-Castell Polychromos

Manganese Violet No. 160

Alizarin Crimson No. 226

Lemon No. 107

Moss Green No. 168

Mauve No. 249

Delft Blue No. 141

Dark Magenta No. 125

Deep Red No. 223

Rose Carmine No. 124

Zinc Yellow No. 104

Permanent Green Olive No. 167

Juniper Green No. 165

Green Gold No. 268

Paper
Smooth Cartridge Paper
210gsm (100lb)
Tracing paper

Additional equipment
As for Project One

Aims To produce a small drawing of spring flowers, using an iris, a red tulip and a yellow tulip, arranged in an artistic pose.

Finished size of my drawing:
18 x 13cm (7⅛ x 5⅛in)

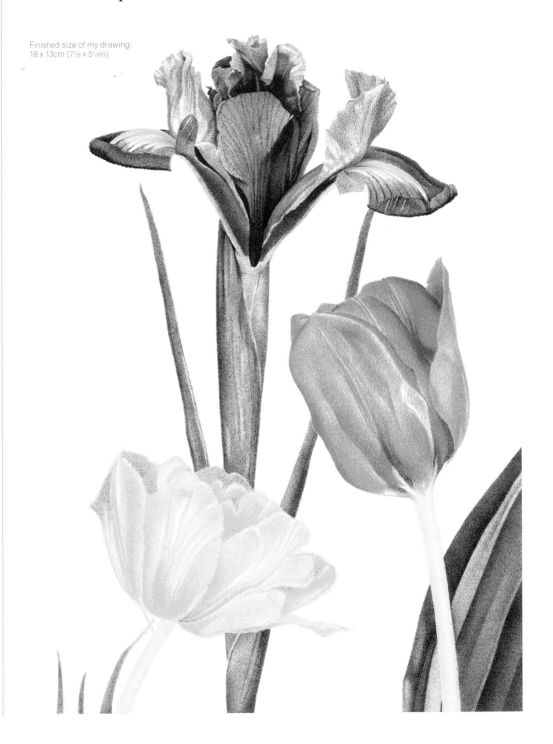

Notes to remember

Flowers in a vase don't necessarily give you the best arrangement for an artistic pose. Instead of using a vase, lay them out flat on a table and photograph them individually, then scan the photos into a computer and rearrange them into different positions until you have a layout you are happy with, and print the layout out and use it as your design, but work from the actual flowers.

If you don't have a camera or computer, lay your flowers out flat on a table top and rearrange them until you have a layout you're happy with. Sketch the outline of the flowers on to paper, then put the flowers back into water and study them individually as you work on them, holding them close if necessary to see the fine details.

There's no right or wrong order when working on the individual subjects in a drawing. Sometimes I work on more than one subject at a time, and at other times I finish one subject or area before moving on to another. For this demonstration, I have broken the stages down in a way to help you see each flower individually, but if you prefer, you can work on all three flowers at the same time, developing each at the same pace.

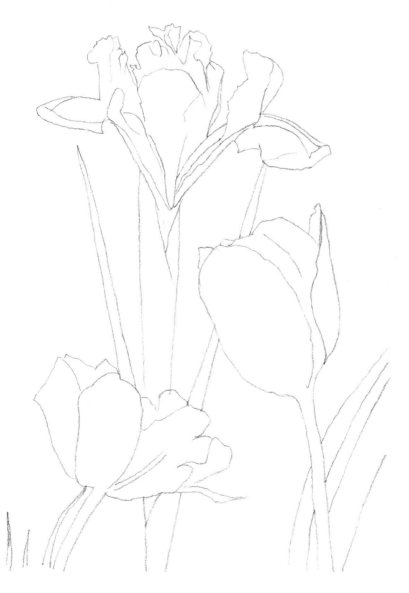

Possible problems with the reference

Getting the overall layout right (see above).

Finishing each of the flowers before it wilts and dies.

Drawing Flowers

When drawing flowers, keep them as fresh as possible by storing them in water containing a suitable cut-flower food (usually available as a powder to mix with the water).

You may also find that storing cut flowers in a refrigerator overnight will help to keep them alive for longer.

If a flower does wilt and die while you are drawing it, don't worry. Sinply buy another flower of the same colour and variety, and substitute any unfinished areas with ones taken from the new flower – nobody will know except you!

Project Three

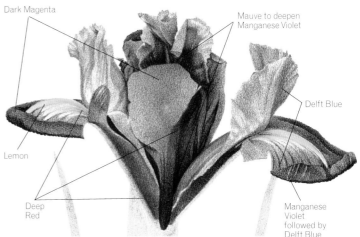

Dark Magenta

Mauve to deepen
Manganese Violet

Delft Blue

Lemon

Deep
Red

Manganese
Violet
followed by
Delft Blue

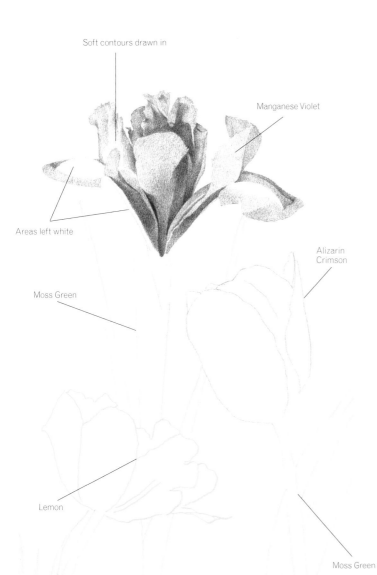

Soft contours drawn in

Manganese Violet

Areas left white

Moss Green

Alizarin
Crimson

Lemon

Moss Green

2 I started to deepen the colour to create a more three-dimensional shape and to give the flower head more form. I strengthened the overall colour by adding another layer of Manganese Violet with a little more pressure, and I used a layer of Mauve to deepen the colour for the inside of the flower head. I used a *very, very, light* layer of Delft Blue on the petals to give then a blue tint, and added a layer of Dark Magenta to brighten up all the petals, plus a small amount of Deep Red on the inner right-hand shadow area to give it some warmth. Finally, I used Lemon for the yellow on the petals and then used Deep Red for the veins on the yellow and Manganese Violet to draw in the veins on the petals, adding a touch of Delft Blue for the colour on and between the veins. I also started to block in the colour of the stem and the leaves using a *light* layer of Moss Green.

1 The first stage was to trace the three flowers out followng the sketch on the previous page, using a mid-tone colour for each flower. I used Manganese Violet for the iris, Alizarin Crimson for the red tulip and Lemon for the yellow tulip. I used Moss Green for all stalks and leaves, then blocked in a base layer of Manganese Violet for the iris flower head, being careful to reserve the white of the paper for the areas that were to be a different colour. I drew in some soft individual strokes to create the contours and folds of the petals.

Combination of Rose
Carmine and Deep Red
used to deepen colour
all over

Manganese
Violet followed
by Deep Red

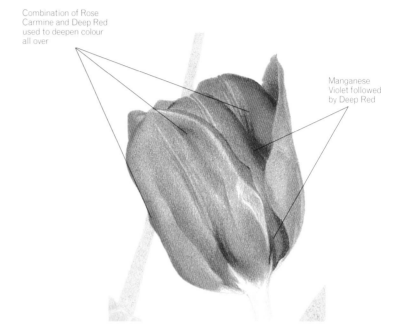

Alizarin Crimson applied
with varying pressure

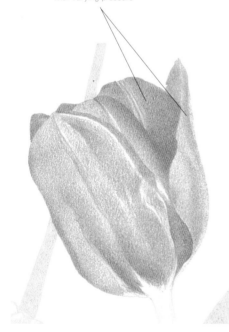

4 I deepened the colour to create a more rounded, waxy look to the shape of the petals and flower head, blending a combination of Rose Carmine and Deep Red, alternating between the two colours until I had the depth of colour I wanted. For the shadow areas I used a layer of Manganese Violet, followed by a layer of Deep Red to brighten up the colour.

Tip

If you intend to draw a flower or piece of fruit over a period of time, and prefer to draw from life, it still pays to take a photo at a time when you're happy with the light source. That way, you have a permanent record of the shadows, however subtle they may be.

3 I now started to block in the red tulip flower head, using a layer of Alizarin Crimson for the overall base colour. I varied the pressure required to create the different contours of the petals, applying more pressure for the shadow areas. Moss Green was continued on the leaves and Zinc Yellow on the stalks.

Project Three

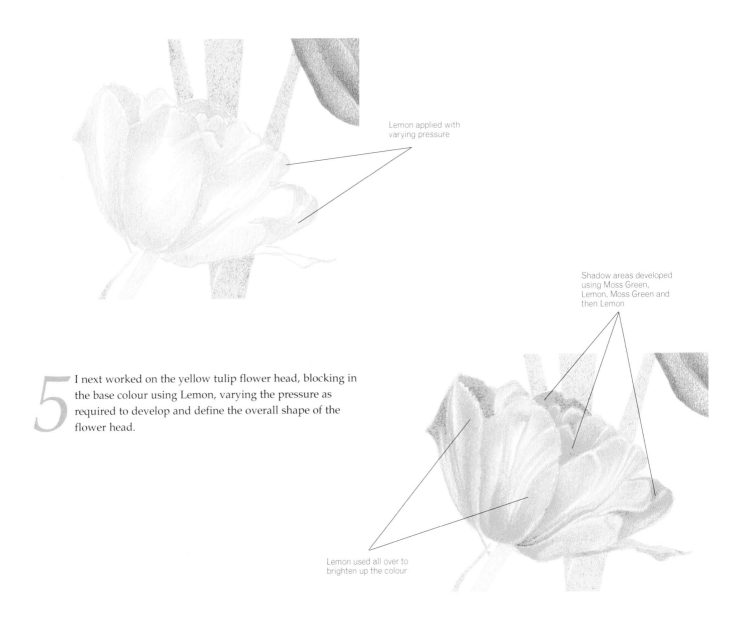

Lemon applied with
varying pressure

Shadow areas developed
using Moss Green,
Lemon, Moss Green and
then Lemon

Lemon used all over to
brighten up the colour

5 I next worked on the yellow tulip flower head, blocking in
the base colour using Lemon, varying the pressure as
required to develop and define the overall shape of the
flower head.

6 I now used a *very, very, light* layer of Moss Green for the
shadow areas to define the shape, and then continued to
deepen the shadow areas, alternating between Lemon and
Moss Green. I then used a layer of Lemon over the shadow
areas to blend all the colours together, and to brighten up the
flower head and create more of a waxy look.

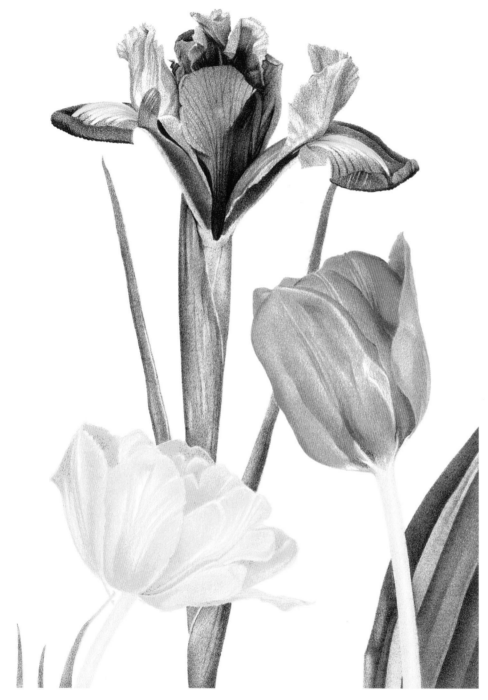

Q Having just finished drawing a cluster of rose heads with their leaves, I've placed a mount on the picture, but the finished drawing looks very top-heavy. I've spent hours on the flowers and leaves and don't want to crop it, but there's a large empty space in the bottom right-hand corner. What can I do?

A Drawing can be immensely absorbing, and it's easy to spend hours on the drawing and forget about the composition. Often it's only when we mount or frame the finished drawing that we can see areas to which we need to make changes. Botanical artists often include a small detailed study of a flower bud, flower seed or individual leaf. To include a study of something like this won't take hours to draw, and will both add interest and fill the empty space.

7 I further developed the colouring of the stalks and leaves. For the iris I used Moss Green for the base layer, and then added a layer of Zinc Yellow to brighten the colour, followed by a *light* layer of Permanent Green Olive, to add depth and for the vertical markings on the stalk, and Juniper Green for the shadow areas. I then added another *light* layer of Zinc Yellow to brighten the

colour up again, and applied touches of Green Gold where the stalk has a tint of brown. For the tulip stalk I used a base layer of Zinc Yellow, followed by a *very, very, very light* layer of Moss Green. For the leaves I combined Permanent Green Olive, Green Gold and a *light* layer of Moss Green, varying the pressure and combinations of the colours. Finally I added veins to the iris petals using Manganese Violet and then I fixed the drawing.

PROJECT FOUR: STUDY OF A CONE

MATERIALS

Pencils
Derwent Studio

Raw Umber No. 56

Silver Grey No. 71

Brown Ochre No. 57

Venetian Red No. 63

Ivory Black No. 67

Gunmetal No. 69

Vandyke Brown No. 55

Copper Beech No. 61

Faber-Castell Polychromos

Black Soft No. 99

Paper
Smooth Cartridge Paper
210gsm (100lb)
Tracing paper

Additional equipment
Kneaded putty eraser
Pencil sharpener
Fixative

Aims To capture the form, shape and texture of a pine cone, using colour and tone. Nature contains some wonderful objects that make great subjects for small works of art.

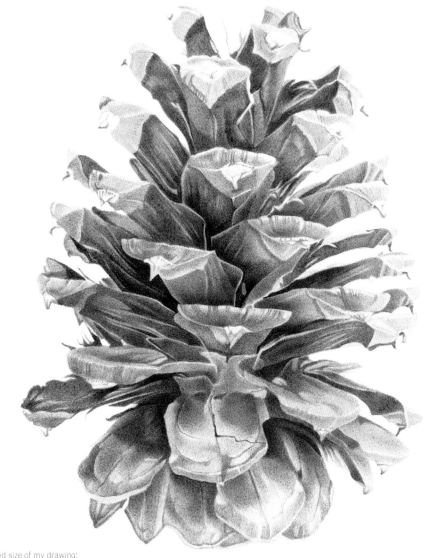

Finished size of my drawing:
14.5 x 11.5cm (5³⁄4 x 4¹⁄₂in)

Notes to remember

Objects incorrectly drawn can look flat, not realistic or three-dimensional. The first thing when attempting a detailed object is to get the basic drawing right by observing the form. The arms of a pine cone are wider at the tips than at the centre, and the drawing needs to reflect this. The light colour of the tips also helps to bring them to the forefront, while the shadow areas create depth. By getting the right balance between depth of colour and shadows, the object will appear more realistic.

Because the shape of a pine cone is quite complex, it can be an intimidating object to attempt. If you find drawing it freehand too difficult a task, take a photo of the cone and trace the main outline. You will not be cheating, because the success of completing a good finished piece still relies on how well you use your skills as an artist to block in the colours and shapes and create a realistic-looking, three-dimensional object. I used a tracing for this picture, because I wanted to save time in the early stages.

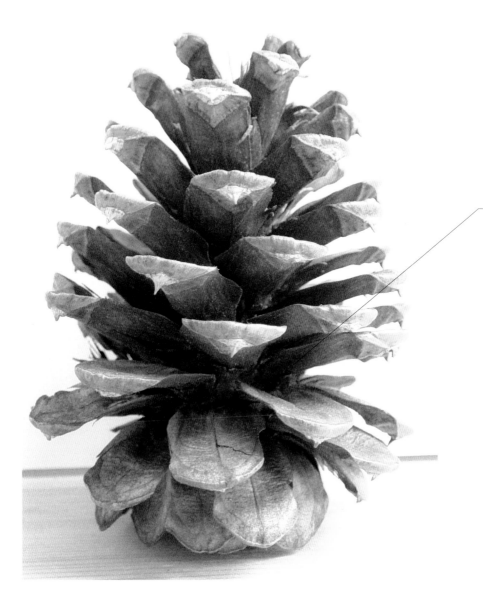

Possible problems with the reference

Getting the basic shape right.

Drawing the arms correctly.

Capturing the characteristic texture.

Applying the right amount of colour and pressure to develop the shadow areas.

Tip

With complicated subjects, it's important to sit back occasionally and compare the drawing with the reference, to check that everything is in the right place.

Project Four

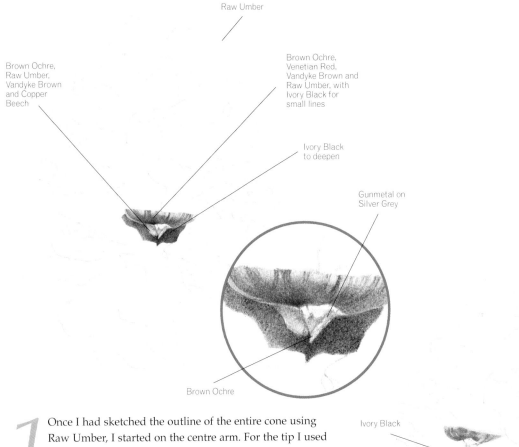

Raw Umber

Brown Ochre,
Raw Umber,
Vandyke Brown
and Copper
Beech

Brown Ochre,
Venetian Red,
Vandyke Brown and
Raw Umber, with
Ivory Black for
small lines

Ivory Black
to deepen

Gunmetal on
Silver Grey

Brown Ochre

Brown Ochre, Venetian
Red, Vandyke Brown and
Raw Umber, with Ivory
Black for small lines on
all arm ends

Ivory Black

Silver Grey, Gunmetal
and Brown Ochre

Tip

Just nine pencils were used in this project, but because all artists apply their pencils differently, practise the colour combination and number of layers on a separate piece of paper first until you get it right. Remember to keep the layers *very light* and soft.

1 Once I had sketched the outline of the entire cone using Raw Umber, I started on the centre arm. For the tip I used Silver Grey, with Gunmetal to draw in the lines to define the shape. At the very tip, I used a touch of Brown Ochre. I then used Brown Ochre, Venetian Red, Vandyke Brown and Raw Umber for the ends of the arm, using Ivory Black for the small dark lines. On the underside of the tip/arm I used Brown Ochre, Raw Umber, Vandyke Brown and Copper Beech. Ivory Black was added to the underside of the arm to deepen the colour and create the shadow areas.

Q Do I have to block in the entire base colour first before going on to the next colour?

A No - you can work on isolated areas and happily leave the work for any length of time without having to worry about colours drying too fast.

When working on a complex subject such as this, it actually helps to complete a small area first, before progressing to other parts of the drawing. This way you can develop a method in how to apply the pencils, getting the layering and colour combinations right before getting carried away with the whole thing and possibly spoiling it.

2 Having decided to block in a small, but complete area of cone before progressing further, I started on five other arms, concentrating on the ends of the arms and tips first. Again, for the tips I used Silver Grey, Gunmetal and Brown Ochre. For the ends of the arms the colours were Brown Ochre, Venetian Red, Vandyke Brown and Raw Umber, alternating between all four colours using a combination of blocks of colour and lines to develop the correct colour and texture. Ivory Black was used for the small individual, dark lines.

Brown Ochre, Venetian Red, Vandyke
Brown, Copper Beech and Raw Umber
on undersides of arms, with Ivory Black
to deepen colour and shadows

Brown Ochre, Vandyke Brown,
Copper Beech and Raw Umber
on undersides of tips

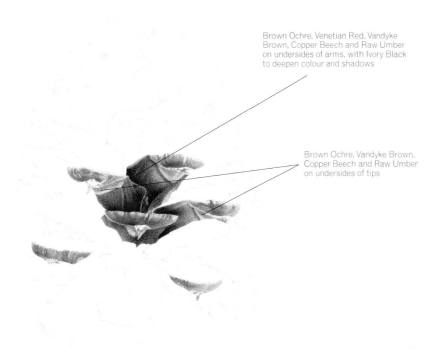

Silver Grey,
Gunmetal and a
touch of Brown
Ochre on tips

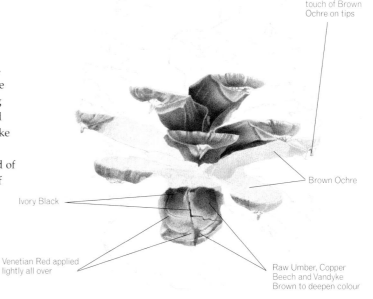

Brown Ochre

Ivory Black

Venetian Red applied
lightly all over

Raw Umber, Copper
Beech and Vandyke
Brown to deepen colour

3 I now started to block in the underside of the tips and
arms. For the underside of the tips I used Brown Ochre,
Raw Umber, Vandyke Brown and Copper Beech. For the
arms, I blocked in a layer of Brown Ochre, then, leaving
some fine lines of the Ochre showing, I also added Venetian Red
for warmth, followed by Raw Umber, Copper Beech and Vandyke
Brown. Ivory Black was used to deepen the colour and shadow
areas, especially towards the centre of the cone. For the very end of
the tips I used Silver Grey, and added Gunmetal with touches of
Brown Ochre to define the shape.

4 I now started working on more of the arms, using Brown
Ochre as the base colour followed by a *very light* layer of
Venetian Red to add warmth. The tips were drawn in
using Silver Grey, Gunmetal and Brown Ochre. The arm
colour was deepened using Raw Umber, Copper Beech and
Vandyke Brown, and the lines to depict the texture were drawn in
with Vandyke Brown. I deepened the lines using Ivory Black.

Project Four

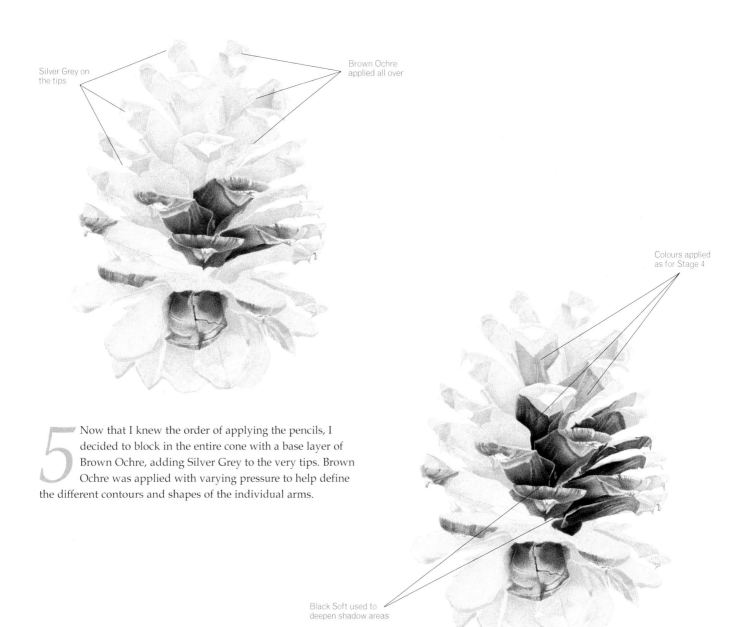

Silver Grey on
the tips

Brown Ochre
applied all over

Colours applied
as for Stage 4

Black Soft used to
deepen shadow areas

5 Now that I knew the order of applying the pencils, I decided to block in the entire cone with a base layer of Brown Ochre, adding Silver Grey to the very tips. Brown Ochre was applied with varying pressure to help define the different contours and shapes of the individual arms.

6 I continued to block in the arms, and introduced Black Soft, a wonderfully soft black pencil that works exceptionally well over a number of pencil layers, to deepen the inner dark shadow areas. These areas are important, because as the shadows are deepened the centre of the cone becomes darker, giving the impression that it's receding. This helps the lighter ends of the arms to stand out and creates the illusion that the arms are growing outwards, above and below each other. This in turn creates a more rounded overall shape and three-dimensional look.

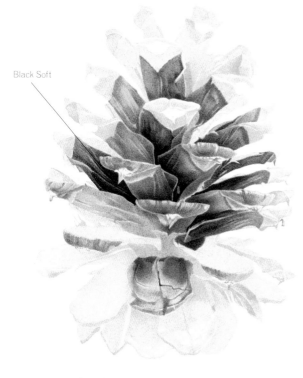

Black Soft

7 As the other arms were completed, I developed their inner shadow areas further, using Black Soft.

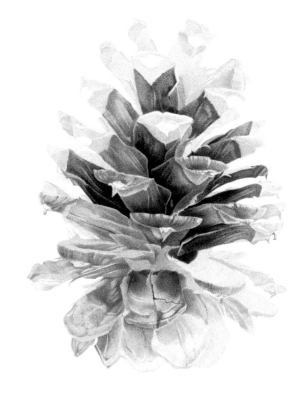

8 I continued to block in the rest of the cone, using a combination of Brown Ochre and Venetian Red to create warmth prior to adding the other colours – see Stage 2 for the colours used on the ends of the arms, Stage 3 for the colours used on the undersides of the arms/tips, and Stage 4 for the colours of the arms.

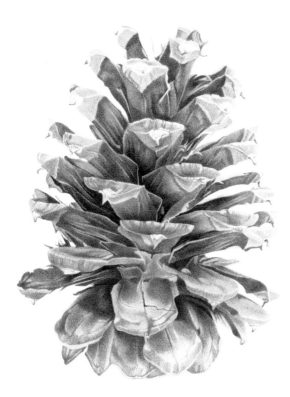

9 I finished the colouring of the cone and added some individual lines to the tips and arms. Finally, I darkened the colours and shadows where necessary. I then lightly applied a couple of coats of fixative.

PROJECT FIVE: BLACK-AND-WHITE CAT

MATERIALS

Pencils
Faber-Castell Polychromos

Black Soft No. 99

Burnt Sienna No. 283

Payne's Grey No. 181

Raw Umber No. 180

Lemon Cadmium No. 105

Light Violet No. 139

Orange Yellow No. 109

Pink Madder Lake No. 129

Brown Ochre No. 182

Sky Blue No. 146

Olive Green Yellowish No. 173

Cold Grey II No. 231

Paper
Smooth Cartridge Paper
210gsm (100lb)
Tracing paper

Additional equipment
As for Project One

Aims To capture the look and characteristics of a 14-year-old domestic, short-haired cat in three-quarter profile, creating soft, short hair and white fur and whiskers.

Finished size of my drawing:
11 x 8.5cm (4¹/₄ x 3¹/₄in)

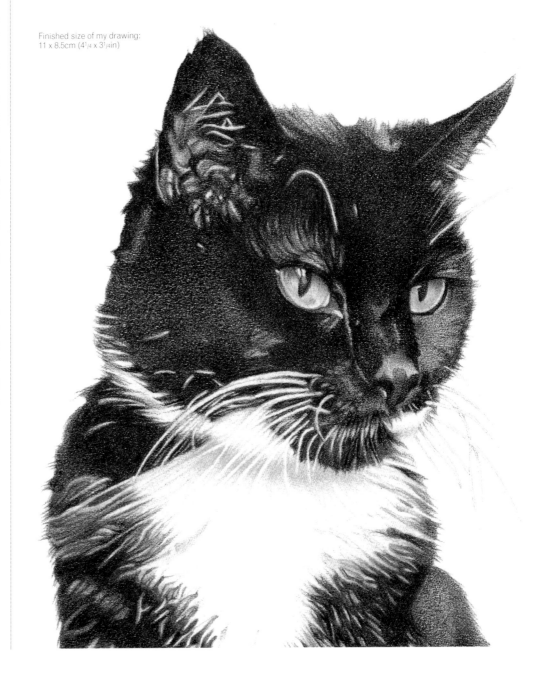

Notes to remember

I took this photo, but because it is out of focus, I had to pay particular attention to the details of the cat's features, and ensure that I had the angle of the head right in relationship to them.

I also wanted to take out the collar as it was too overpowering. This, in fact, was easy to do – I simply had to continue the white fur of the chest into the neck line.

For help when attempting this project, refer to Creating Whites on pages 26–29, Highlights: Eyes on pages 31–32, and Project One: Cat's Eyes on pages 38–43.

Q I have spent hours on this drawing, and I have noticed that the eyes are uneven and out of line. How can I make sure that the angle is always right?

A This simple exercise will help to resolve the problem. Lay the tracing paper on top of your reference photograph, and then use a pencil and ruler to draw lines across the top and bottom of the eyes, across the ears and nose and below the chin. You can then place this tracing over your initial drawing to check that the features you are drawing do actually fall upon the lines.

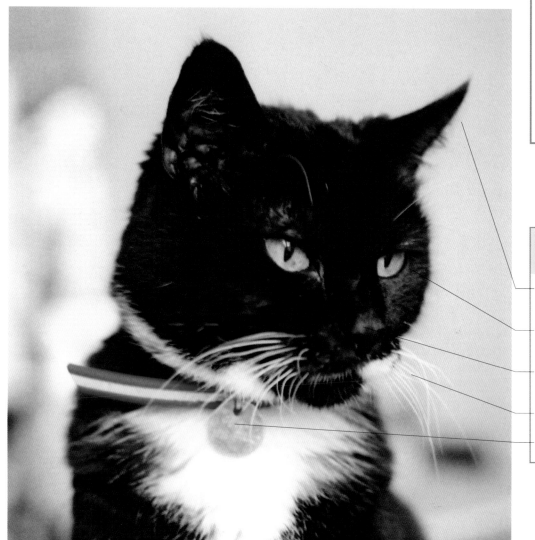

Possible problems with the reference

The reference photo is out of focus.

Getting the angles of the head and features right.

Lack of definition in areas such as the nose.

White whiskers.

Collar not wanted.

Project Five

Lemon Cadmium
followed by
Orange Yellow

Olive Green Yellowish

Brown Ochre

Black Soft

Burnt Sienna

Brown Ochre

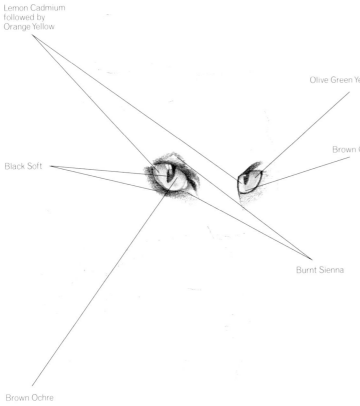

Individual hairs
left white

Raw Umber

Payne's Grey
followed by
Black Soft

Burnt Sienna

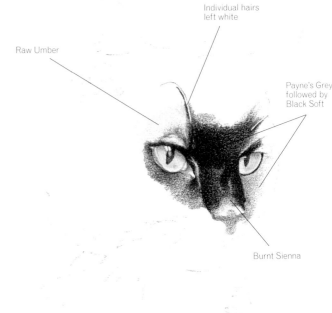

1 After tracing out the outline and main features, and working *very lightly*, I used Black Soft for the pupils of the eyes, being careful to leave the highlights showing as the white of the paper. Then I added a *soft, light* layer of Lemon Cadmium as the base colour to bring an overall brightness to the eye, followed by Orange Yellow for warmth. I then used Brown Ochre to draw in the stronger marks in the eye and to deepen the eye colour at the top and sides. I then added Olive Green Yellowish to the tops of the eyes to create shadow, blending it down and around the outside to create more shape. Next I applied Burnt Sienna to the inner corner of the right eye, and above the right eye. I then started to block in the fur around the eyes using Black Soft.

2 I continued to block in the fur using a *light* layer of Payne's Grey followed by Black Soft, concentrating on the nose first and being careful to draw in the characteristic individual white hairs of the eyebrows (see page 26). Because the picture is relatively small, it was important to suggest the changes in colour and texture, rather than trying to capture all the details exactly, so I paid particular attention to where and how the colouring changes. I added a *light* layer of Raw Umber for the right eyebrow, plus a *light* layer of Burnt Sienna to the top of the nose, before adding the Payne's Grey and Black Soft.

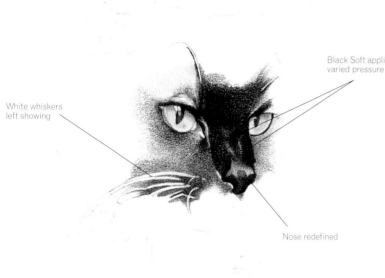

White whiskers
left showing

Black Soft applied with
varied pressure

Nose redefined

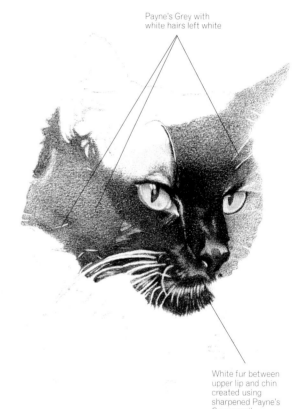

Payne's Grey with
white hairs left white

White fur between
upper lip and chin
created using
sharpened Payne's
Grey pencil

3 I continued to block in the fur, applying Black Soft with
varied pressure to develop the shape and contours of the
face and being careful to leave the white whiskers
showing. The markings on the bridge of the nose were left
light and the edges were darkened to define the shape. I also
redefined the shape of the nose.

Tip
Keep your tracing near
to hand at this stage; you
can lay it on your
drawing to double-check
that everything is correct
and in order. It can also
act as a guide when
putting in individual
hairs and whiskers.

4 I continued to block in the base layer of Payne's Grey on
the rest of the picture, applying more pressure to the
darker areas. Even at this stage, the cat begins to take on
its round, three-dimensional shape. It is worth taking time
over this stage because all marks have to be observed carefully,
with white hairs and whiskers left as the white of the paper. Areas
of fine white fur between two black areas – for example, where the
upper lip meets the chin – also need to be well observed. I left the
paper untouched for the white fur and drew in some very fine
lines of Payne's Grey for the black fur, using a very sharp pencil.

Project Five

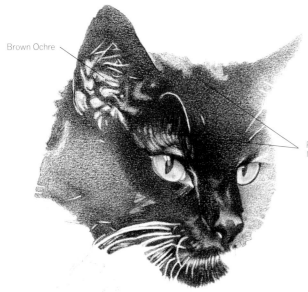

Brown Ochre

Payne's Grey to block in base
layer and for individual hairs

Sky Blue, Light
Violet and Cold
Grey II

Brown Ochre
and Raw Umber

Payne's Grey applied in
blocks of colour and
individual lines

5 I completed blocking in the base layer of fur on the head using Payne's Grey. For the area depicting the inside of the ear, I added a *light* layer of Brown Ochre. I then drew in some individual hairs to depict the eyebrow.

Tip
When you have a white object lying on a white surface there will be some changes in colour – no two whites will look exactly the same, especially if a light source is falling upon them. In this drawing, I decided to draw the whiskers in and to make them more prominent than the white background, but subtle colouring is called for.

6 I now started to block in the chest and body fur using Payne's Grey, alternating between blocks of colour and individual lines to distinguish between the black and white areas. To deepen and develop the white fur where it meets the black fur, I used *light* strokes of Sky Blue and Light Violet to add colour, then used Cold Grey II, Brown Ochre and Raw Umber to deepen the colour.

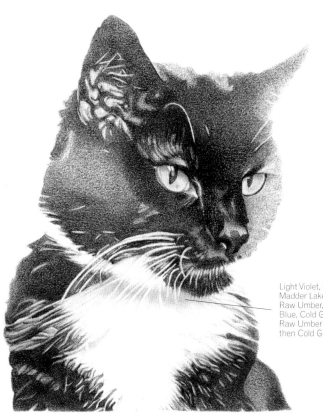

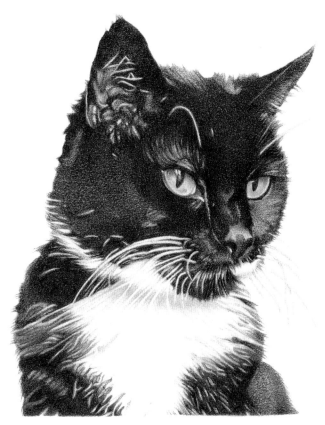

Light Violet, Pink Madder Lake, Raw Umber, Sky Blue, Cold Grey II, Raw Umber and then Cold Grey II.

7 I finished blocking in the base layer of Payne's Grey and drawing in the fine white fur against the black. Next, I concentrated on blocking in the shadow area under the chin by applying *very light* alternate layers of Light Violet, Pink Madder Lake, Raw Umber, Sky Blue, Cold Grey II and then a *very delicate* touch of Raw Umber, finally darkening down with Cold Grey II.

8 I now blocked in the whiskers that appear against the white blackground. Initially I drew the whiskers in using Payne's Grey. Then, with my eraser I gently dabbed at the pencil mark until only a faint line was visible. I then added colour to warm up the white whiskers against the cooler background. Applying the pencil *very lightly*, I used Lemon Cadmium, added Pink Madder Lake and then gently dabbed off excess pencil to achieve a subtle colouring. For the white fur around the whiskers I used a little Sky Blue, Pink Madder Lake and then some Raw Umber. Cold Grey II and Black Soft were used to add shadow and to draw in the delicate black fur at the outer edge of the upper lip. Next, I toned the inner ear and eyebrows down with a soft layer of Burnt Sienna, followed by Black Soft. Then I went over the eyes, strengthening the colour of both the eyes and the eye sockets, adding Black Soft for the shadows. I added tiny fine individual hairs to give the fur a soft look around the outer edges, then darkened the black fur using a *very soft, light* layer of Black Soft.

PROJECT SIX: COLLECTION OF MATERIALS

MATERIALS

Pencils

HB pencils
Prismacolor (Karismacolor)
Dark Green No. 908
Indigo Blue No. 901
Olive Green No. 911
Black No. 935
Scarlet Lake No. 923
Carmine Red No. 926
Poppy Red No. 922
White No. 938

Verithin
Apple Green No. 738 ½
Poppy Red No. 744

Paper

Fabriano 5 HP Paper
600gsm (300lb)
Tracing paper

Additional equipment

As for Project One plus
00000 watercolour brush
White watercolour pencil

Aims To make a well-balanced, pleasing picture using different types of material in a range of colours that are similar and therefore work well together.

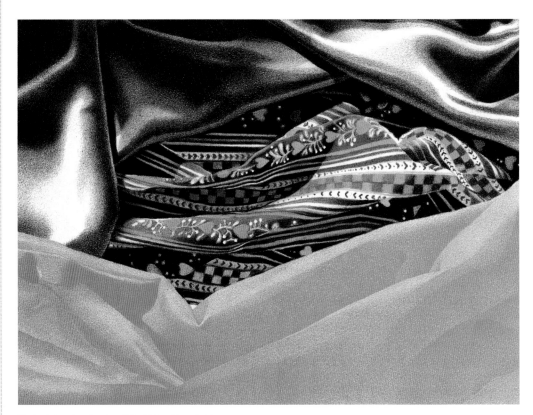

Finished size of my drawing: 11.5 x 15.5cm (4½ x 6⅛in)

Notes to remember

Initially the composition and variety of materials may appear daunting, but with careful planning the project is relatively easy. Here, the materials were a green satin, patterned red, green and white cotton, and plain red cotton, all purchased at the same time so that I could check that the colouring was similar.

The plain cotton was approached and drawn in a similar way to the satin, with the pencils blended and graduated in the same way, but without the strong highlights and sheen of satin. The patterned cotton relied on a more flat application of pencil, with the addition of dark shadow areas to depict strong folds and creases.

I arranged the materials in a number of different ways to get the best balance, and took photos using different light sources, from natural sunlight to flash. That way, not only did I have a permanent record of the layout, but I could also compare the different photos to see which light source I preferred for the final drawing. I liked the strong contrasts in this photo, and the challenge of re-creating the look of three different textured materials, each with interesting creases and folds.

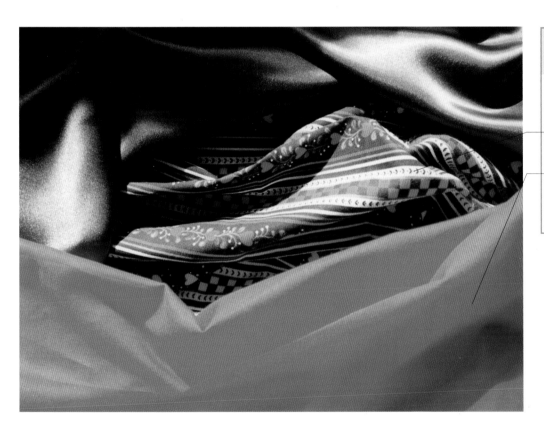

Possible problems with the reference

Capturing the look of three different materials.

Complex pattern needs to be observed carefully.

Giving each material an equal amount of space so that the composition is well balanced.

Project Six

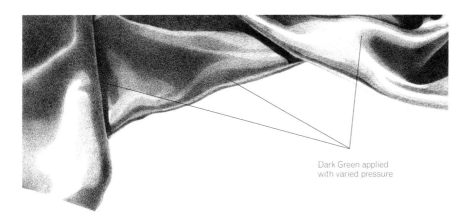

Dark Green applied
with varied pressure

1 Having traced out the initial outlines of the materials, I started on the satin. Drawing in the plain materials first makes it easier when it comes to drawing in the patterned material. I blocked in the initial layer of Dark Green, applying it with varied pressure and graduating it into the light areas so that there were no harsh lines.

Tip

Pick a selection of materials that work well together to create a pleasing picture. If you use a piece of material with a complicated pattern, keep the other materials simple, and if you mix patterns, choose ones that have a common denominator – for example, red, green and white stripes will work well with a red and white check so long as the reds are similar in colour and do not clash. The easiest way to see if materials work together is to lay them alongside and upon each other.

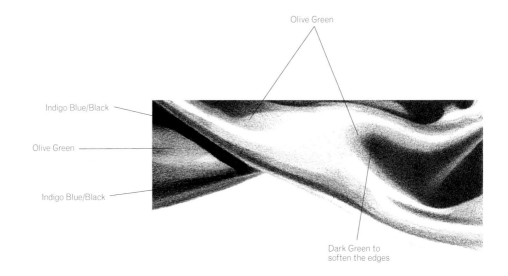

Olive Green

Indigo Blue/Black

Olive Green

Indigo Blue/Black

Dark Green to
soften the edges

2 A *very soft, light* touch was necessary for this stage, as I didn't want to overwork the colour. I started by applying a *light* layer of Indigo Blue to create the shadow areas, followed by Olive Green to brighten up the light areas, graduating and blending the two colours together. I then used Black over the Indigo Blue, and Dark Green to soften any harsh edges, alternating between these colours to build up the depth and tone of colour. Olive Green was then used to soften the strongest highlights.

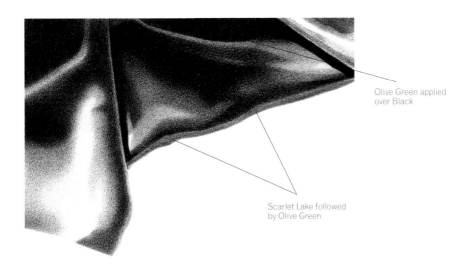

Olive Green applied
over Black

Scarlet Lake followed
by Olive Green

3 To finish the satin, I applied a layer of Olive Green over the Black, and added soft touches of Scarlet Lake at the bottom edges where the colour is reflected off the red cotton, before toning this down using Olive Green.

Scarlet Lake applied
with varied pressure

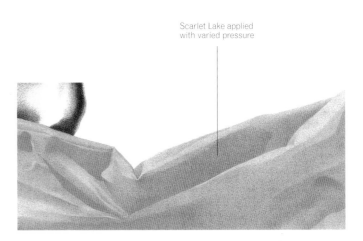

4 I lightly traced out the outline of the red cotton using the mid-tone colour of Scarlet Lake, using the same colour to block in the base layer. Because the look of the material is dull in comparison to the shiny satin, I applied the pencil all over, graduating it with varying pressure, so that no white paper was left showing. For the darker-toned areas it was important to keep the pencil sharp, so that as much of the tooth of the paper as possible was filled in, giving the material a solid look.

Project Six

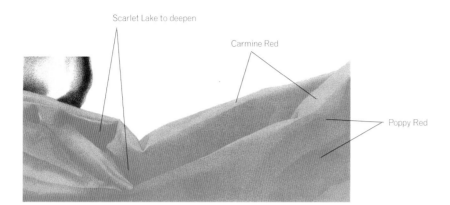

Scarlet Lake to deepen

Carmine Red

Poppy Red

5 Carmine Red was used for the light areas that had a pink tint to them, then I applied Poppy Red over the rest of the material to add warmth. Finally, Scarlet Lake was used to deepen the colour again.

Verithin Apple Green for outline of green pattern

Scarlet Lake

Verithin Poppy Red for outline of red pattern

Indigo Blue, Dark Green then Indigo Blue

Q **I'm doing a drawing of a cat, working from a photo. The cat is lying upon a cushion on a sofa. The cushion is made from a tapestry fabric with an intricate pattern, the sofa is made from a cut velvet material, and the cat is a tabby! The whole scene looks very busy, and everything clashes. What can I do to make the finished drawing easier on the eye?**

A It's very easy to think that you have to draw exactly what you see in your reference photos, but the beauty of being an artist is that you can change things to suit you. The cat is the most important thing in the drawing. The easiest object to change would be the cushion – keep the shape exactly the same, retaining all the folds and creases, but replace the pattern with a single colour that works well with the colouring of the cat and sofa. You can even change the colour of the sofa if you want.

6 Initially, the patterned cotton appeared quite complex and difficult, so I drew the outline of the pattern in first, and then almost finished a small area before continuing to block in the rest. Because the pattern was so detailed, I used fine-point Verithin pencils for the outlines – Poppy Red for the red hearts, squares and stripes, and Apple Green for the outline of the decorative leaf pattern and the outline of the white lines. After drawing the outlines I started to block the colours in, using Scarlet Lake for all the red, and *very light* layers of Indigo Blue, followed by Dark Green, then Indigo Blue again for the green areas.

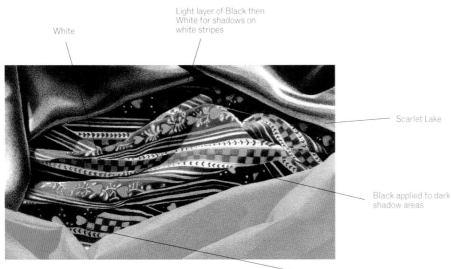

White

Light layer of Black then White for shadows on white stripes

Scarlet Lake

Black applied to dark shadow areas

Scarlet Lake, Black, Scarlet Lake for red shadow area

7 I continued to block in the patterned material using a combination of *light* layers. For the green I used Indigo Blue, Dark Green and Indigo Blue, and for the red, Scarlet Lake. For all areas that had light falling upon them I added a *soft, light* layer of White to tone the colour down. For all the dark green shadow areas I applied Black *very lightly*. For the shadow areas, where the plain red material opposite had cast the shadow, I initially applied a layer of Scarlet Lake all over, followed by a *light* layer of Black, then added Scarlet Lake again to all the red pattern. To deepen the dark green shadow areas, I alternated between Black and Indigo Blue, and added a layer of Scarlet Lake along the edge of the green satin material, which had red reflecting off it. For the shadow areas on the white stripes, I added a *very light* layer of Black, and then burnished it flat using White, creating a grey.

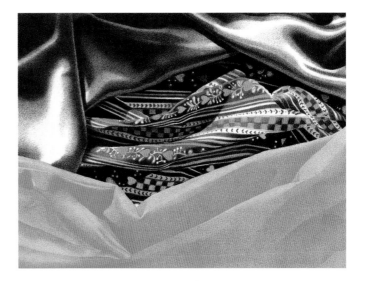

8 The final stage was to create more of a contrast between the light and dark areas. To deepen the shadow areas still further I used Black, and to lighten the light areas I used White. I also tightened up some of the pattern using the original colours, and because the tiny white dots on the green needed strengthening, I dissolved a white watercolour pencil with some water and applied it using a very fine (00000) watercolour brush (alternatively, you could use Zest-It). I then fixed the drawing using fixative.

PROJECT SEVEN: EAGLE OWL

MATERIALS

Pencils
HB pencil
Lyra Rembrandt Polycolor

Sky Blue No. 46

Black Medium No. 99

Lemon Cadmium No. 5

Canary Yellow No. 8

Dark Orange No. 15

Vermilion No. 17

Black Hard No. 299

Cool Silver Grey No. 96

Light Violet No. 39

Medium Grey No. 97

Deep Colbalt No. 43

Cool Dark Grey No. 98

Van Dyke Brown No. 76

Brown Ochre No. 82

Juniper Green No. 65

Sap Green No. 67

Paper
Smooth Cartridge Paper
210gsm (100lb)
Tracing paper

Additional equipment
Kneaded putty eraser
Pencil sharpener
Fixative

Aims To capture the inquisitive character in the face of an eagle owl, including the feathers, beak and eyes.

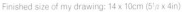

Finished size of my drawing: 14 x 10cm (5½ x 4in)

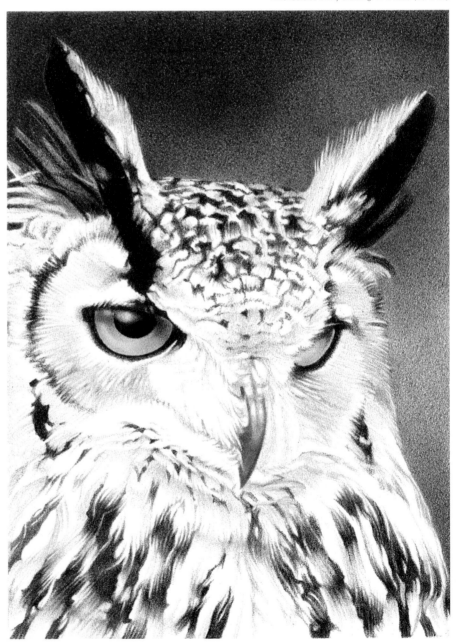

Notes to remember

It can be difficult to get decent photos of birds of prey. if they are kept in an enclosure at a wildlife park, you cannot get as close as you would like. If you have to zoom in close to try and capture as much detail as possible, there may be barely visible, out-of-focus wide lines across the photo, both vertically and horizontally. These are lines of the wire enclosure, which can make the feathers seem faded.

It's important to bear these things in mind when taking photos of animals that are obscured by wire or glass. Don't be tempted to draw exactly what you see unless you know they are characteristics of the animal – I obtained better photos of the same breed of owl to check the colouring and details for this project.

One of the early decisions I made when thinking about this project was that I wasn't going to worry too much about drawing each feather faithfully – this wasn't going to be a scientific, natural-history drawing. I was more interested in capturing the inquisitive look, so the drawing wasn't going to be too complex, and by breaking the drawing down into smaller stages, it became easier.

With all animals I start with the eyes first, then progress on to the other features. So, although I initially drew the whole picture out on to the tracing paper, I started with the eyes, including the highlights, and beak.

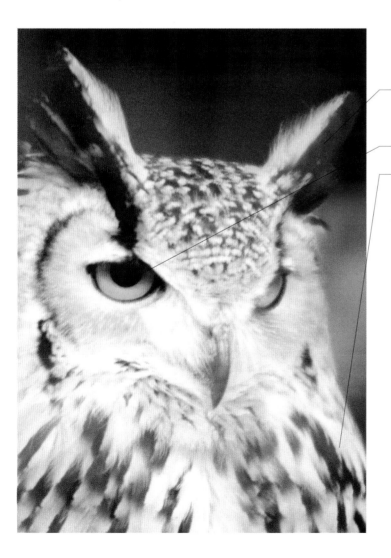

Possible problems with the reference

Areas appear faded, due to being obscured by the wire of the enclosure.

No highlight in eyes.

Capturing the look of the feathers without being too scientific.

Tip

I take all my own owl photos when visiting country fairs or birds of prey rescue centres, where all the birds are cared for by reputable organisations. The birds perch happily and are easy to photograph, but if I want a photo with more action, I ask the proprietor if it would be possible to take photos of the owl with its wings open. Most are more than happy to oblige.

Project Seven

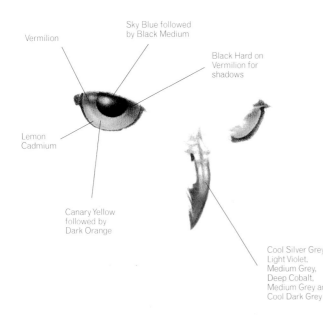

Vermilion

Sky Blue followed by Black Medium

Black Hard on Vermilion for shadows

Lemon Cadmium

Canary Yellow followed by Dark Orange

Cool Silver Grey, Light Violet, Medium Grey, Deep Cobalt, Medium Grey and Cool Dark Grey

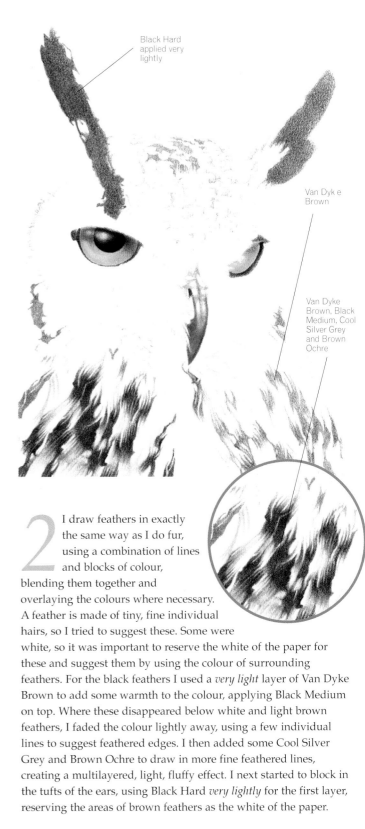

Black Hard applied very lightly

Van Dyke Brown

Van Dyke Brown, Black Medium, Cool Silver Grey and Brown Ochre

1 The eyes are cast in shadow, but to capture a realistic, glassy look I needed to add a highlight. So I drew one in, following the contours of the eyelid. It was to be quite soft to suggest a slightly overcast sky, so before adding the black of the pupil, I added a *very light* layer of Sky Blue. I then used Black Medium for the pupil. For the eye I used a *light* layer of Lemon Cadmium. I then added a layer of Canary Yellow, followed by Dark Orange to add warmth, which I blended down around the shape of the eye to give it a more rounded, three-dimensional look, leaving a fine line of yellow showing along the lower eyelid. Vermilion was then blended into the Dark Orange. Black Hard was used to soften the edges of the highlight. To create the shadow areas, I alternated between Vermilion and Black Hard. For the beak, I used a combination of Cool Silver Grey, Light Violet, Medium Grey, Deep Cobalt, Medium Grey and Cool Dark Grey, in that order.

Tip
The black of the feathers shouldn't appear too solid and heavy, so keep a kneaded putty eraser nearby to lift off excess pencil pigment.

2 I draw feathers in exactly the same way as I do fur, using a combination of lines and blocks of colour, blending them together and overlaying the colours where necessary. A feather is made of tiny, fine individual hairs, so I tried to suggest these. Some were white, so it was important to reserve the white of the paper for these and suggest them by using the colour of surrounding feathers. For the black feathers I used a *very light* layer of Van Dyke Brown to add some warmth to the colour, applying Black Medium on top. Where these disappeared below white and light brown feathers, I faded the colour lightly away, using a few individual lines to suggest feathered edges. I then added some Cool Silver Grey and Brown Ochre to draw in more fine feathered lines, creating a multilayered, light, fluffy effect. I next started to block in the tufts of the ears, using Black Hard *very lightly* for the first layer, reserving the areas of brown feathers as the white of the paper.

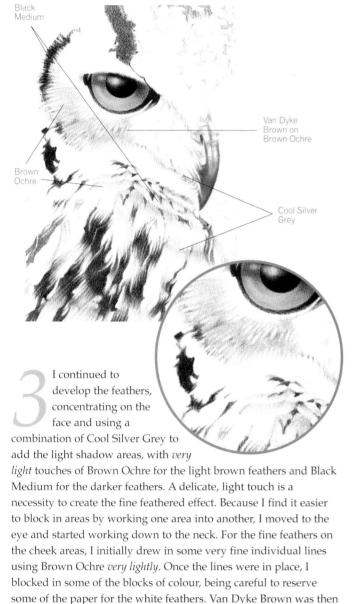

Black
Medium

Van Dyke
Brown on
Brown Ochre

Brown
Ochre

Cool Silver
Grey

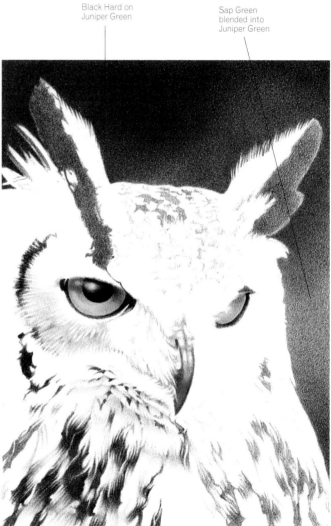

Black Hard on
Juniper Green

Sap Green
blended into
Juniper Green

3 I continued to develop the feathers, concentrating on the face and using a combination of Cool Silver Grey to add the light shadow areas, with *very light* touches of Brown Ochre for the light brown feathers and Black Medium for the darker feathers. A delicate, light touch is a necessity to create the fine feathered effect. Because I find it easier to block in areas by working one area into another, I moved to the eye and started working down to the neck. For the fine feathers on the cheek areas, I initially drew in some very fine individual lines using Brown Ochre *very lightly*. Once the lines were in place, I blocked in some of the blocks of colour, being careful to reserve some of the paper for the white feathers. Van Dyke Brown was then used for some of the darker individual fine feathers. Around the beak I drew in some fine, soft feathers using Cool Silver Grey.

4 I next blocked in the background colour so that the outline of the Owl was more visible and thus easier to work on. To suggest foliage without having to draw individual trees and leaves, I used a layer of Juniper Green, followed by a *light* layer of Black Hard for the dark green around the top of the head, and Sap Green applied *lightly* down and around the right-hand side, graduating and blending the two colours together. This gave the impression of light shining through the foliage. Black Hard was added to the bottom right-hand corner.

Project Seven

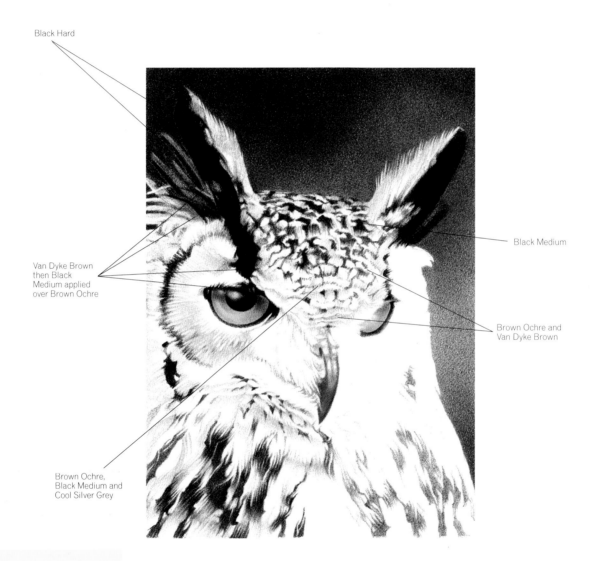

Black Hard

Van Dyke Brown
then Black
Medium applied
over Brown Ochre

Black Medium

Brown Ochre and
Van Dyke Brown

Brown Ochre,
Black Medium and
Cool Silver Grey

Tip

For the lines and
feathers on and over the
contours of the face and
cheek, you may find it
easier to turn the picture
around so that your hand
flows easily in these
directions.

5 I continued with the feathers on the head, using a
combination of Brown Ochre, Van Dyke Brown and Black
Medium. To create the look of the feathers on the head I
blocked in patches of colour, alternating between the
Brown Ochre and Van Dyke Brown. For the deep brown areas
around the ears and eyes I added Van Dyke Brown followed by
Black Medium. For the black feathers of the ears I used Black
Hard, and for the markings on the head, which are small fine
feathers, I used a combination of Brown Ochre, Black Medium and
Cool Silver Grey.

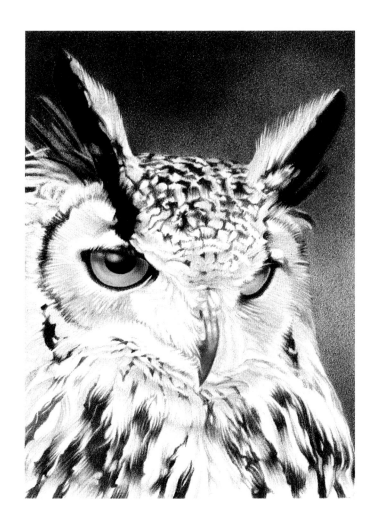

6 I completed blocking in the left-hand side, alternating between Brown Ochre, Black Medium, Black Hard, Cool Silver Grey and Van Dyke Brown to develop the depth of tone and colour needed. I used very small strokes of Sap Green to break up the hard edge of the face and to create a fine feathered look. I then darkened the eyelids and softened the edges to suggest very fine small feathers, and deepened the shadows in the eyes, using Black Hard.

Q **I want to draw a barn owl, but because the bird is so light in colouring, I'm not sure what to do for a background. I don't want to do anything too complicated.**

A It's easier to complete drawings when you have the right reference. This means researching your subject matter as thoroughly as possible. I would look through good books on owls for inspiration and ideas on backgrounds. One of the easiest backgrounds for a barn owl would be to simply block in a very dark blue, almost black, background to suggest either the inside of a dark timber building or the night sky. If you're unsure of what to do, work on the owl first, then when it's nearly finished, get a colour photocopy done and practise the background on that, not the original. That way, you won't make a mistake that will be impossible to correct.

PROJECT EIGHT: STUDIES OF NATURE

MATERIALS
Pencils
HB pencil
Faber-Castell Polychromos

Ochre No. 184

Venetian Red No. 190

Van Dyck Brown No. 176

Burnt Umber No. 280

Caput Mortuum No. 169

Cinnamon No. 189

Cold Grey II No. 231

Cold Grey IV No. 233

Cold Grey V No. 234

Payne's Grey No. 181

Orange Yellow No. 109

Sanguine No. 188

Pink Madder Lake No. 129

Lemon No. 107

Indian Red No. 192

Burnt Sienna No. 283

Light Sepia No. 177

Dark Sepia No. 175

Raw Umber No. 180

Brown Ochre No. 182

Paper
Smooth Cartridge Paper
210gsm (100lb)
Tracing paper

Additional equipment
As for Project One

Aims To produce a small decorative work of art, using two shells, a pebble and a small piece of driftwood, selected for their variety of colour, texture and size.

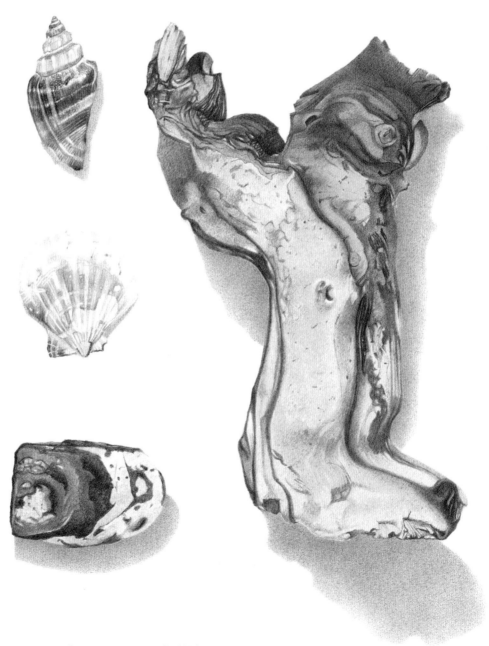

Finished size of my drawing: 20 x 15.5cm (8 x 6¹⁄₈in)

Notes to remember

Nearly all natural-history subject matter contains very fine, intricate details and markings. These are the characteristics that make drawing them not only a challenge, but an extremely interesting one. Sometimes, though, some of the detail can be difficult to see, but there are a couple of things you can do to make things easier. First, use a magnifying glass – so long as the main features are already drawn in on the actual drawing, it's easy to add the small details. Second, photograph the object and have it enlarged, then use it the same way as above.

It's important to prevent objects from appearing flat, and to make them look three-dimensional. If you decide to set up a small still life in a similar way to the project illustrated, i.e. on a flat white background, but you don't want to include the shadows, you need to have stronger contrasting light and dark areas and shadows to create more of a three-dimensional shape. Make notes or take photos of the objects while they're cast in a strong light, either natural or artificial. That way, you have a permanent record should the light fade.

Possible problems with the reference
Capturing the fine details.
Making the objects look three-dimensional.
Positioning the objects so that a well-balanced layout is achieved.

Project Eight

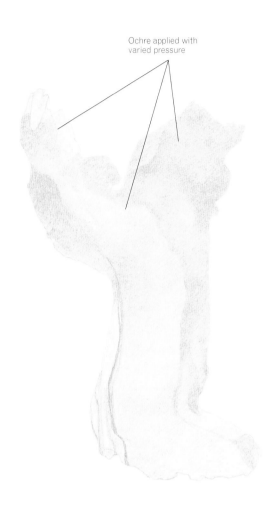

Ochre applied with
varied pressure

Base layer of Ochre

2 I continued to block in the Ochre to create a deeper mid-tone colour, using slightly more pressure for the darker areas so that when the next colour was added, it would produce a richer colour.

1 I often prefer to block in part of each object first before finishing one complete piece. In this case, I started with the driftwood, the biggest item, working it up to be half-finished before starting on the next object (if you prefer to finish one piece at a time, simply skip to the stage that describes that object's next step). I sketched the outline then blocked in a *light* base layer of Ochre to give the wood an overall warm glow.

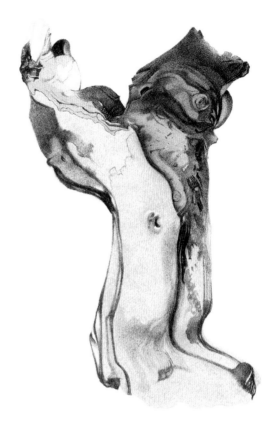

Van Dyck Brown and
Burnt Umber applied
over Venetian Red

Venetian Red

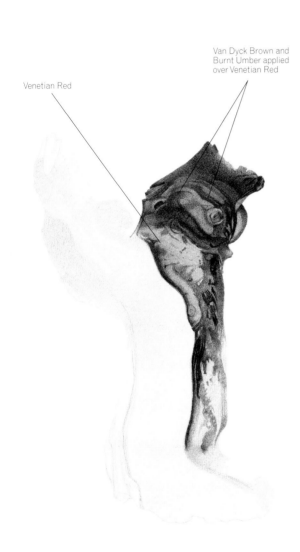

4 I continued to develop the colour, shape and texture of the
wood, correcting and altering the shape where necessary. I
introduced Caput Mortuum to enrich the brown, and
added Van Dyck Brown and Burnt Umber to strengthen
the colour of the darker markings. I then added Cinnamon to the
areas that had been left as Ochre, applying a *light* layer, both to
tone the colour down slightly and to warm it up. I then went back
over with Ochre in places to deepen the colour. The wood now
had its distinguishing character, so I started work on the next
object.

3 I now started to add the deeper red and brown colours to
develop the characteristic strong textures and markings of
the wood, starting with Venetian Red. I then used a
combination of Van Dyck Brown and Burnt Umber for the
strong, dark brown lines and marks. For the colour in between, I
applied Venetian Red in a sketchy, light way to create a textured
effect. This also allowed the base colour of the Ochre to show
through. I alternated between these two colours until the right
depth of tone had been achieved.

Project Eight

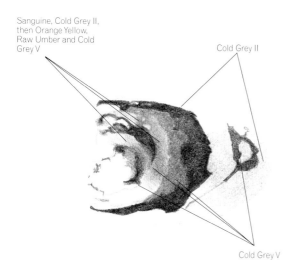

Sanguine, Cold Grey II,
then Orange Yellow,
Raw Umber and Cold
Grey V

Cold Grey II

Cold Grey V

5 Because the pebble in the bottom left-hand corner was so small, I blocked in as much of the base colour as possible – after sketching the outline out using Cold Grey II, I used Payne's Grey for the darkest grey area, Cold Grey V for the mid-grey area, and Cold Grey II for the lightest grey area. For the marble-like area at the side, I blocked in a layer of Cold Grey II, added a layer of Orange Yellow all over that, drew in the two small distinguishing marks on the left using Sanguine, and then went over the whole area using Raw Umber. The colours were all applied *very lightly* so that each colour appeared transparent and shone through. I then went over the area using Cold Grey V, applying the pencil with tiny, sketch-like marks to strengthen the marble colour.

Same colours as Stage 5

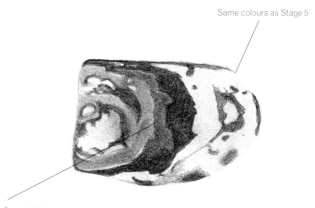

Payne's Grey added
over Cold Grey V

6 I continued to block in the pebble, alternating between the colours used in Stage 5. I added texture by using the pencils in a sketchy way and going over the previously laid colours to deepen them. I also added a *light* layer of Payne's Grey to the mid-grey area to darken it slightly.

Cinnamon and Indian Red

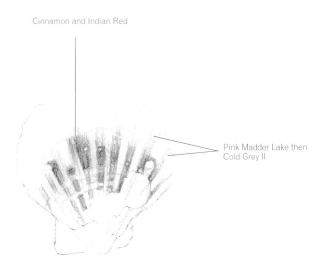

Pink Madder Lake then
Cold Grey II

7 I sketched the fan shell out using an HB pencil and
started to block in the base colour to define the fan shape
and ridges, using Pink Madder Lake and Cold Grey II for
the lighter ridges, and Cinnamon and Indian Red for the
darker ones. I left the patches of white upon the shell as the white
of the paper at this stage.

Brown Ochre

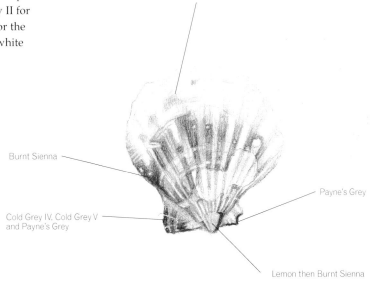

Burnt Sienna

Payne's Grey

Cold Grey IV, Cold Grey V
and Payne's Grey

Lemon then Burnt Sienna

Tip
To get the colour
combination and order in
which the pencils should
be applied, practise on a
spare piece of paper first.

8 I continued to block in the fan shell using the same
colours as in Stage 7, adding Brown Ochre for the brown
areas and a combination of Cold Grey IV, Cold Grey V and
Payne's Grey for the grey areas along the bottom, and to
deepen the colour of the ridges. I added Burnt Sienna for the dark
red on the outer edge and applied a touch of Lemon to the tip at
the bottom of the shell, with Burnt Sienna for the small mark.

Project Seven

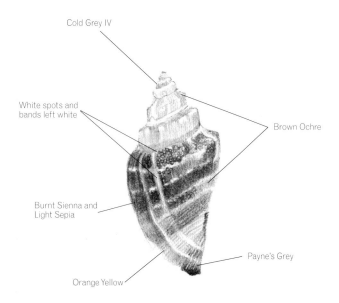

Cold Grey IV

White spots and
bands left white

Brown Ochre

Burnt Sienna and
Light Sepia

Payne's Grey

Orange Yellow

9 The small cone-shaped shell at the top had a combination of vertical and horizontal bands and lines, plus blocks of colour, so I developed the shape and colour from the very start. At the bottom I applied a *light* layer of Orange Yellow and used Brown Ochre for all of the light brown areas. For the darker brown areas I applied Burnt Sienna, followed by Light Sepia. Cold Grey IV was used for all the grey, with Payne's Grey added at the bottom. It was important to apply the pencils in a way so that the small characteristic white spots (left showing as the white of the paper) and bumps were also starting to develop.

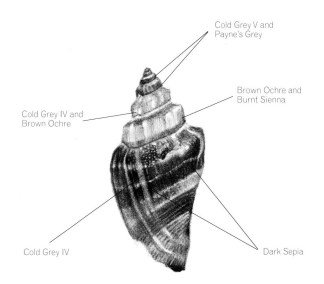

Cold Grey V and
Payne's Grey

Brown Ochre and
Burnt Sienna

Cold Grey IV and
Brown Ochre

Cold Grey IV

Dark Sepia

10 I deepened the colours of the cone shell with lines and blocks of colour, applying the same colours as Stage 9 with a little more pressure. I introduced Dark Sepia for the darkest brown bands, and toned down the vertical white markings using Cold Grey IV. To deepen the small brown section at the top of the cone I used a combination of Brown Ochre and Burnt Sienna, and for the next smallest brown section I used Cold Grey IV and Brown Ochre. I used Cold Grey V and Payne's Grey for the top two sections.

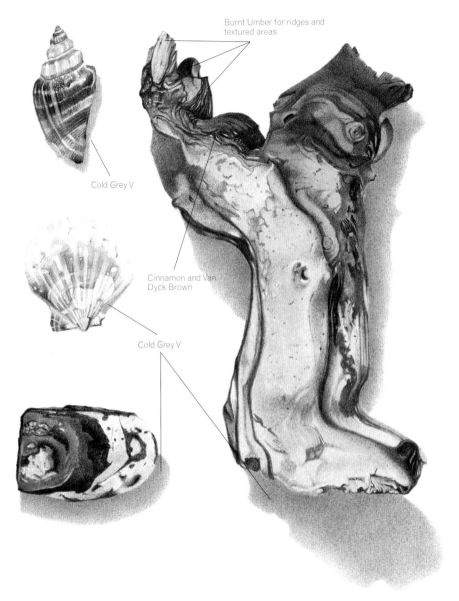

Burnt Umber for ridges and textured areas

Cold Grey V

Cinnamon and Van Dyck Brown

Cold Grey V

A I would choose a fabric that is natural in its look and colour, such as cotton, flax, linen or hessian. The texture and colour of a heavy-duty hessian sack, available from builders' merchants, would contrast beautifully with the soft colours of shells and pebbles, and would be an interesting object to draw in its own right.

11 I now completed all the pieces. The colours and combination were exactly the same for the strong lines and markings on the driftwood as those listed in Stages 3 and 4. I then drew the ridges and textures that could be seen at the top using a very sharp Burnt Umber. The colour was then blocked in using a combination of Cinnamon and Van Dyck Brown. I continued to alternate between the three colours to add more of the overall texture. All the objects were now at a stage where they just needed a few more details to be added and the colours deepened to finish the drawing. The last thing I did was to add shadows to all of the objects, using Cold Grey V. Because the driftwood was bent in the middle and only the top and bottom parts actually sat on the paper, adding shadows helped to convey this shape better. I then lightly fixed the drawing.

PROJECT NINE: PORTRAIT OF A SWAN

MATERIALS

Pencils
HB pencil
Faber-Castell Polychromos

Warm Grey III No. 272

Warm Grey IV No. 273

Van Dyck Brown No. 176

Black Soft No. 99

Light Ochre No. 185

Pale Geranium Lake No. 121

Orange Glaze No. 113

Dark Naples Ochre No. 184

Light Purple Pink No. 128

Light Phthalo Blue No. 145

Ivory No. 103

Olive Green Yellowish No. 173

Paper
Smooth Cartridge Paper
210gsm (100lb)
Tracing paper

Additional equipment
As for Project One

Aims To capture the grace and elegance of a swan's head and neck, and to depict the colours of white in the shadow areas successfully.

Finished size of my drawing: 16 x 13.5cm (6¼ x 5¼in)

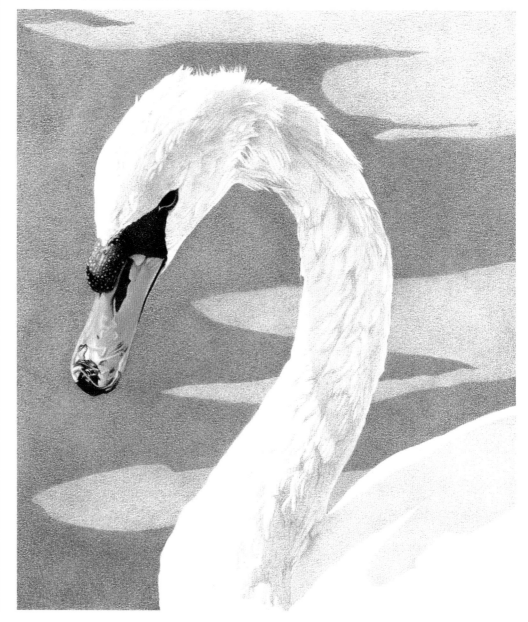

Notes to remember

It can be daunting when choosing a palette of pencils for the different colours of white, as a great many colours can be used to depict the various shades of white that can be seen in an image of this nature (see pages 26–30). In this instance I used five colours.

When I was looking to take my reference photos for this project, I knew that I wanted to take them in strong sunlight so that I would get good contrasting shadows to make drawing the picture easier. It also makes a more interesting picture; otherwise, the whites would appear quite dull and flat. I went to a local waterway where swans were in abundance, and took over 48 photos in the hope of getting 6 or so that would be suitable. I knew that I could amend the background to make it less complicated.

Possible problems with the reference

Distinguishing the different colours of 'white'.

Creating a suitable background without adding unnecessary objects.

Developing shadow areas just enough for the face and eye to be seen clearly.

Project Nine

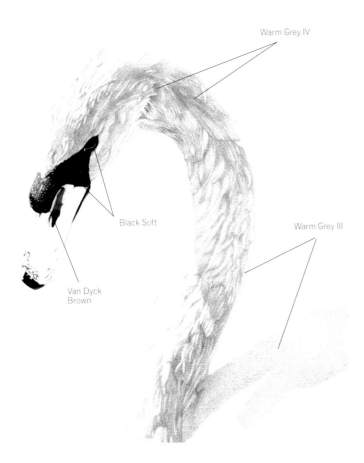

Warm Grey IV

Black Soft

Van Dyck Brown

Warm Grey III

> **Q How do you know where to draw in the grey?**
>
> **A** This is very easy to establish. Change the reference photo to greyscale on your computer screen and then print it out. Don't be afraid of using modern technology to your advantage – it is a tool to be used as you would any other to aid your drawing.

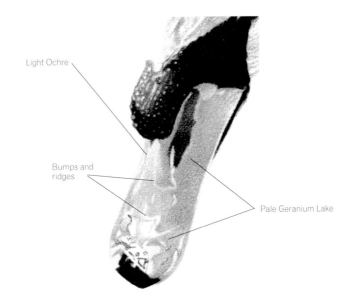

Light Ochre

Bumps and ridges

Pale Geranium Lake

1 I initially traced and drew the outline of the swan and major features, such as the eye, using an HB pencil. Once this was done, I was ready to start blocking in the base layer of colour using Warm Grey III for the light areas, and Warm Grey IV for the darker areas, as a way of establishing the tonal balance between the light and dark areas early on. This technique, known as grisaille, helps to define the shape and form of the object or subject you are drawing prior to adding any colour. This project is a good example of when to use this method, because grey plays an important role in the main colouring of the swan. Once the grey mid-tone base was blocked in, I drew in the eye using Black Soft and started to work on the black areas of the bill and beak. The bill was mainly black, but where the light fell on it there was some warmth to the colour, so I added a *very soft, light* layer of Van Dyck Brown, drawing in the pattern and texture that I could see, then went over it with Black Soft, using a putty eraser to lift some of the colour off and keep the area as light as possible.

2 A beak is a solid object, so I used an initial base layer of Light Ochre after removing the previously drawn outline of the beak using the putty eraser – any colour darker than Light Ochre would dirty it as it was applied, and I wanted to keep the beak colour as bright as possible. I was also careful to reserve the white of the paper at this stage, for the highlights. I blocked in a layer of Pale Geranium Lake, being careful to keep the bumps and ridges showing yellow at this stage.

Orange Glaze over Pale Geranium
Lake, followed by Light Ochre

3 I now added a *soft, light* layer of Orange Glaze over the
Pale Geranium Lake to add warmth and create a richer
orange. I then added a layer of Light Ochre, which helped
to burnish the colours to create a smooth, solid look.

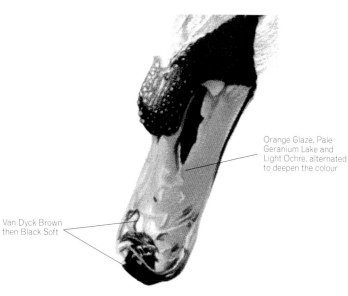

Orange Glaze, Pale
Geranium Lake and
Light Ochre, alternated
to deepen the colour

Van Dyck Brown
then Black Soft

Tip
If you find it difficult to
get small, fine feathers
or other features in the
right place, while you
have a greyscale copy on
your computer screen,
print a copy out on to
acetate or OHP film, as
you would a colour copy,
and use this as a tracing
over your drawing to
check the positions.

4 I finally alternated between the three colours used in Stage
3 to add depth of colour and to define the shape of the
beak. To add strong, darker marks to the beak, I applied
Van Dyck Brown then used Black Soft.

Project Nine

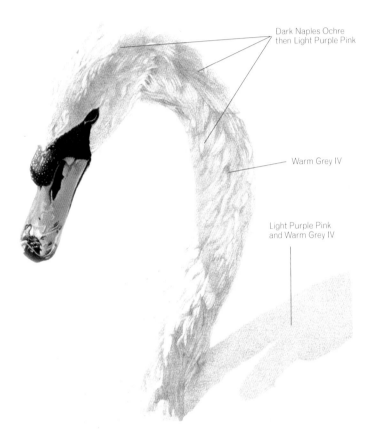

Dark Naples Ochre
then Light Purple Pink

Warm Grey IV

Light Purple Pink
and Warm Grey IV

5 Once the beak was finished I started putting colour into the neck and body with the lightest, brightest colour, Dark Naples Ochre, adding it mainly on the outer edges of the grey. I next added Light Purple Pink over the yellow to create a shade of orange, and used Warm Grey IV to deepen the shadow areas.

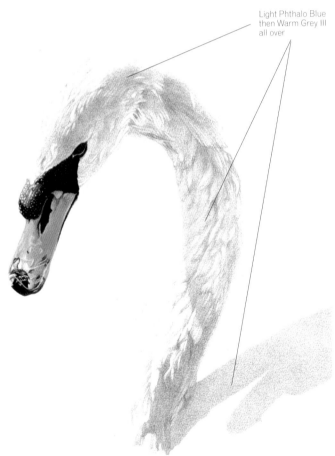

Light Phthalo Blue
then Warm Grey III
all over

6 For the main shadow areas on the body I applied a *very, very light* layer of Light Phthalo Blue, and used smaller amounts of this for the neck. With all the colours in place, I gently dabbed some of the darker colours away using a putty eraser to create more subtle colouring, then I went over them with a *light* layer of Warm Grey III to tone the colours down but to still allow them to show through.

Ivory then Olive Green Yellowish

Olive Green Yellowish

7 I knew it would help to add a background in this picture, as the colour would help to define the white outline of the swan which, due to the strong, bright highlights, made it almost pure white along the right-hand side. If left without a background, the swan would disappear into the white of the paper. I used a *very light* layer of Ivory for the sunlit areas, followed by Olive Green Yellowish, applied heavier for the shadow areas.

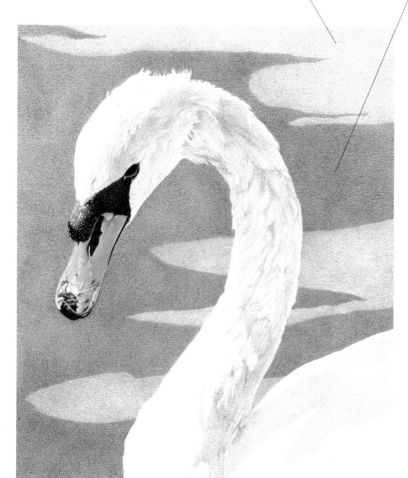

Q **How do you decide on a background, and what can you do if it goes wrong?**

A When I draw animals I rarely put in complicated backgrounds, because I prefer the emphasis to be on the animal. When I do include one, I prefer it to remain simple, using subtle colours and shapes to suggest the animal's habitat. If I'm not sure which background will work best, I do some preliminary layouts first.

The easiest way to do this is to get a colour photo or computer copies of the finished animal and practise different backgrounds on these. This way you avoid damaging the original.

The first background I attempted was dappled and sunlit. I didn't like the effect on this picture, as I felt it distracted the eye from the swan and was too busy. So I used a plastic art eraser to carefully erase most of the colour and redrew the background to suggest simple sunlight being cast upon the grass. If you do get something wrong it can be corrected – but it's better for the picture and the paper not to have to do too much erasing.

PROJECT TEN: APPLE GREEN AND PINKS

MATERIALS

Pencils
HB pencil
Faber-Castell Polychromos

Black Soft No. 99

Middle Cadmium Red No. 217

Rose Carmine No. 124

Burnt Carmine No. 193

Wine Red No. 133

Light Chrome Yellow No. 106

Apple Green No. 170

Light Yellow Ochre No. 183

Raw Umber No. 180

Lemon No. 107

True Green No. 162

Earth Green Yellowish No. 168

Olive Green Yellowish No. 173

Walnut Brown No. 177

Light Magenta No. 119

Fuchsia No. 123

Sanguine No. 188

Light Ochre No. 185

Pink Madder Lake No. 129

Purple No. 194

Caput Mortuum Violet No. 263

Light Red Violet No. 135

Paper
Fabriano 5 HP Paper
600gsm (300lb)

Additional equipment
As for Project One

Aims To draw a still life that has both different textures and colours, including different fabrics with a number of folds and creases.

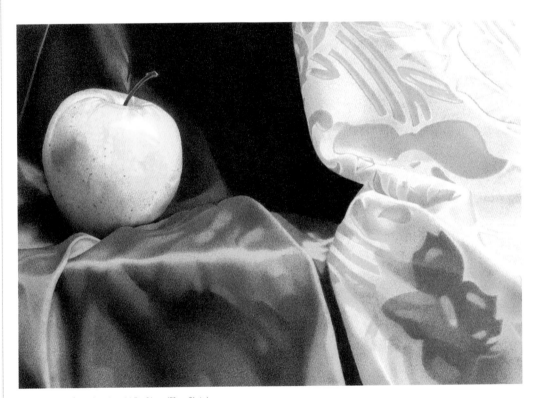

Finished size of my drawing: 14.5 x 21cm (5³/₄ x 8¹/₄in)

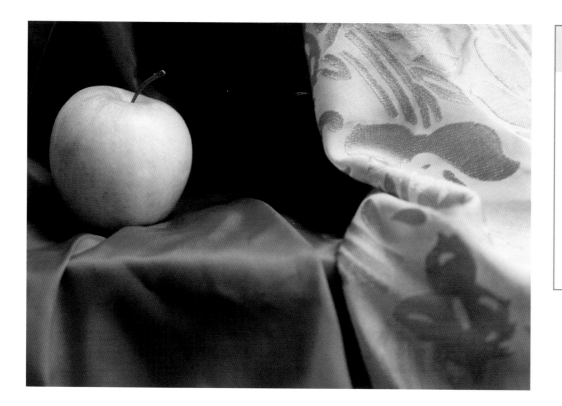

**Possible problems
with the reference**

Getting a good, well-balanced composition.

The photo is slightly out of focus – the drawing needs to be sharp.

Getting the depth of colour right.

Complex composition needs to be broken down into easy-to-follow stages.

Notes to remember

I liked the idea of combining a shiny material with a patterned one, and was elated to find two materials that were not only so different in texture and look (one is satin, the other a cut patterned velvet), but also of a similar colouring. I set the still life up and took photos. In my chosen photo parts of the patterned material were slightly out of focus, yet when looking at the set-up, everything was in focus. It was therefore important to compensate for this,

This picture may initially look too complex and complicated to attempt, but by breaking the stages down

and concentrating on one area at a time, it isn't that difficult. Because each one of these areas is so different and needs to be approached in a different way, it's well worth practising a small area of each on a separate piece of paper first.

It's important to get the depth of colour right to create the contrast between the light of the apple and the dark material, but it's equally just as important not to apply the pencils too heavily too quickly, as you are likely to end up damaging the tooth of the paper and building up a layer of wax or oil. Whichever colour you're working on, build the depth up in many light layers.

Project Ten

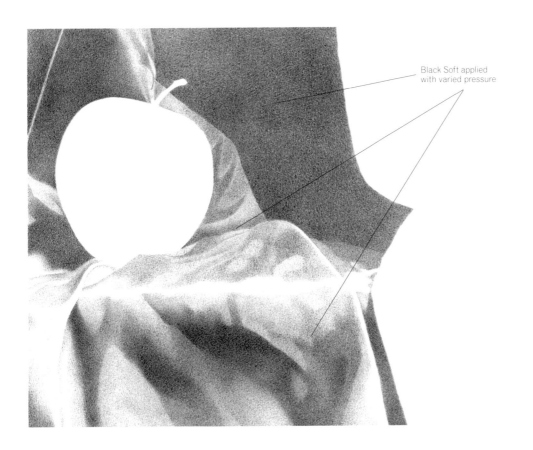

Black Soft applied
with varied pressure

Because the plain pink satin contains a lot of shadow areas
and has a black tint, I first blocked in a base layer of Black
Soft, to establish a tonal balance and because it is such a
strong colour – if it had been applied last, it would have
overpowered the shades of pink. The pencil was applied with
various pressures to create the range of tones, with the paper being
reserved for the lightest highlights. To create the soft edges of the
creases I used the blunt side of the pencil so that the graduation of
tone was gentle and soft, with no hard edges. After blocking the
base colour in, I lightly fixed it to stop the pencil from smudging
too much, and allowed it to dry.

Middle Cadmium Red

I applied Middle Cadmium Red quite heavily for the dark
shadow area in the centre. Because this piece of material is
so dark and solid-looking, I went over the pencil with a
cotton wool bud to smooth the pigment further into the
tooth of the paper.

Black Soft reapplied

3 I reapplied Black Soft with hard pressure to give the
material a solid look. The Middle Cadmium Red was still
showing through, giving the colour a red tint. Once this
was blocked in, I went over the area again *very lightly* with
the cotton bud.

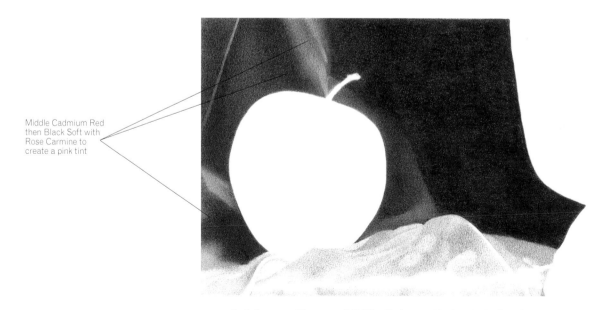

Middle Cadmium Red
then Black Soft with
Rose Carmine to
create a pink tint

4 I alternated between Middle Cadmium Red and Black Soft to block in
the dark areas, applying Black Soft lightly so that the red was still
visible. By working between the two colours and blending them over
the edges of the creases and folds, the colour was deepened and the
edges were softened. I then added a *soft, light* layer of Rose Carmine to give the
material a pink tint.

Project Ten

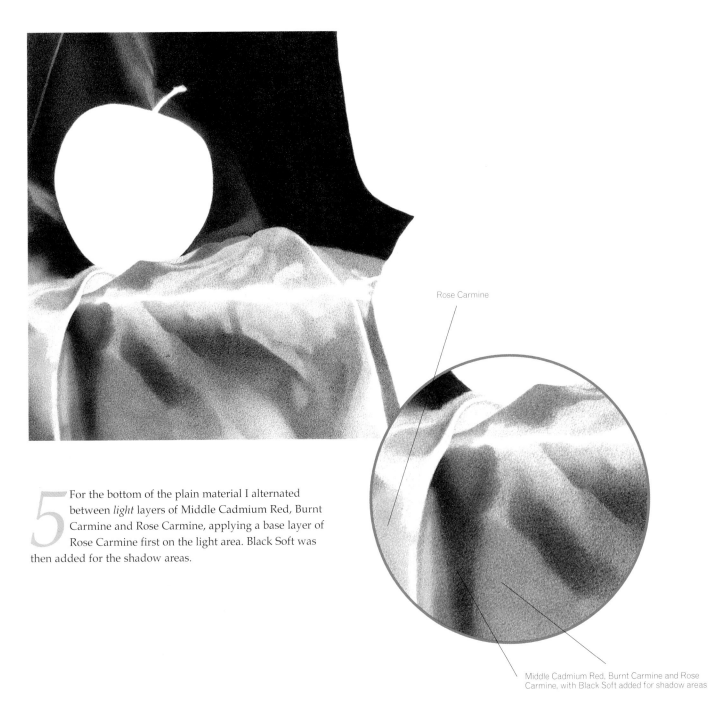

Rose Carmine

Middle Cadmium Red, Burnt Carmine and Rose
Carmine, with Black Soft added for shadow areas

5 For the bottom of the plain material I alternated
between *light* layers of Middle Cadmium Red, Burnt
Carmine and Rose Carmine, applying a base layer of
Rose Carmine first on the light area. Black Soft was
then added for the shadow areas.

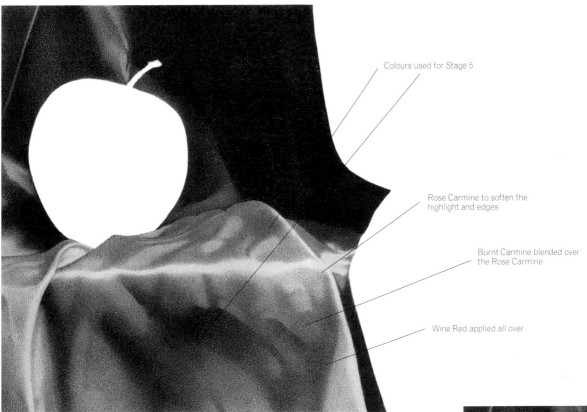

Colours used for Stage 5

Rose Carmine to soften the
highlight and edges

Burnt Carmine blended over
the Rose Carmine

Wine Red applied all over

6 I continued to block in the colours as in Stage 5. A layer of
Rose Carmine was used on the light highlights, and
blended over the darker areas to soften the edges. Burnt
Carmine was then blended over the Rose Carmine. I
added a *light* layer of Wine Red over all the pink.

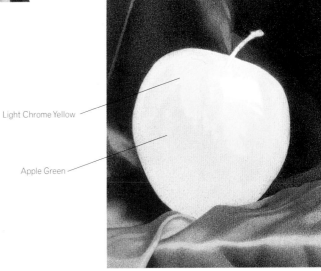

Light Chrome Yellow

Apple Green

7 For the apple, I started with a *soft, light* layer of Light
Chrome Yellow, being careful to reserve the strong
highlight as the white of the paper. I then started to add
Apple Green and alternated between the two colours to
develop the colour and depth of tone and the rounded shape.

Project Ten

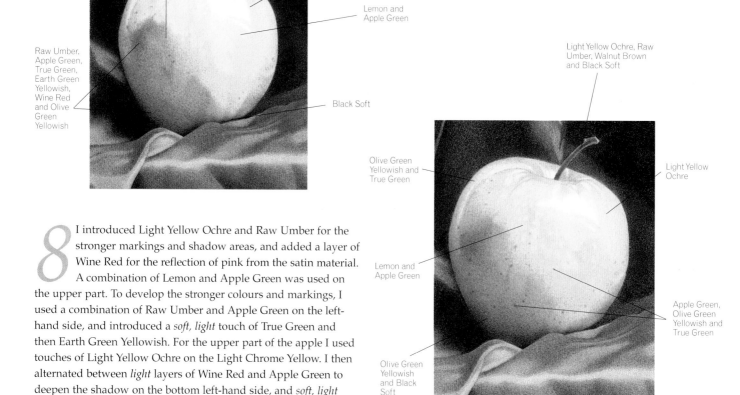

True Green

Raw Umber

Light Yellow Ochre

Lemon and Apple Green

Black Soft

Raw Umber, Apple Green, True Green, Earth Green Yellowish, Wine Red and Olive Green Yellowish

Light Yellow Ochre, Raw Umber, Walnut Brown and Black Soft

Olive Green Yellowish and True Green

Light Yellow Ochre

Lemon and Apple Green

Apple Green, Olive Green Yellowish and True Green

Olive Green Yellowish and Black Soft

8 I introduced Light Yellow Ochre and Raw Umber for the stronger markings and shadow areas, and added a layer of Wine Red for the reflection of pink from the satin material. A combination of Lemon and Apple Green was used on the upper part. To develop the stronger colours and markings, I used a combination of Raw Umber and Apple Green on the left-hand side, and introduced a *soft, light* touch of True Green and then Earth Green Yellowish. For the upper part of the apple I used touches of Light Yellow Ochre on the Light Chrome Yellow. I then alternated between *light* layers of Wine Red and Apple Green to deepen the shadow on the bottom left-hand side, and *soft, light* layers of True Green and then Olive Green Yellowish. I then applied a *light* layer of Black Soft along the bottom to create the strongest shadows.

9 I deepened the bottom left-hand side using Olive Green Yellowish, followed by Black Soft. I then continued to develop the colour and markings of the rest of the apple, redefining the areas of colour where necessary and further developing the apple's three-dimensional shape. Light Yellow Ochre was used over the Apple Green on the right-hand side to warm the area up. For the stalk, I used a base layer of Light Yellow Ochre, with Raw Umber on the outer edges followed by Walnut Brown. I then added a *very light* touch of Black Soft along the centre of the stalk. For the markings on the top, I toned the base colour down slightly using a putty eraser, then added Olive Green Yellowish and True Green. For the dappled texture on the apple skin on the upper part of the apple, I made small circular marks of Lemon, afterwards adding Apple Green. Finally, I used a combination of Apple Green, Olive Green Yellowish and True Green to add the small dots on the skin.

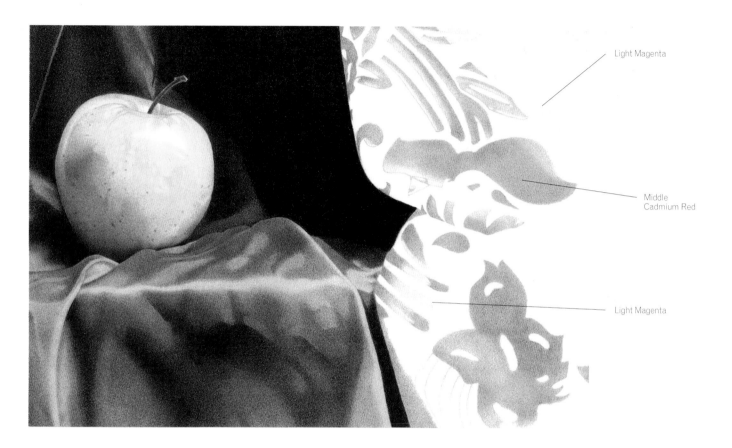

Light Magenta

Middle
Cadmium Red

Light Magenta

10 The design on the patterned material is made of cut velvet, while the background material is a partially transparent thin nylon. It was, therefore, important to create the correct look and to distinguish between the two different textures. I started by blocking in the base colours, using Light Magenta for the pattern with the light falling upon it on the top right-hand side. The pattern in the darker areas was blocked in using Light Magenta for the light area and Middle Cadmium Red for the darker areas.

Tip
The secret of drawing a shiny solid apple successfully is to apply very soft and very light layers, so that the colours appear almost transparent. At the same time there has to be enough colour to give the apple a three-dimensional look, so it's worth practising on a spare piece of paper when using a combination of four or more colours.

Project Ten

Light Magenta

Light Red Violet

Nylon and velvet is developed further
using Light Magenta, Fuchsia, Middle
Cadmium Red and Light Red Violet

11 I started on the various colours of the nylon. The main colour used was Light Red Violet, which was applied with various pressures, depending on the depth of tone required. For the area in the far right-hand corner I applied the colour *extremely lightly*, and then used a putty eraser to lift off some of the colour so that it was as light as possible. I drew in the pattern of the velvet in the top right-hand corner using Light Magenta

12 I now deepened the colour of the nylon. I added a very light layer of Light Magenta all over, and deepened the colour at the bottom by adding Fuchsia. At the bottom, I then went over the velvet with Middle Cadmium Red, and as some of the shadow areas contain reflections of the satin, I added a combination of Light Red Violet and Middle Cadmium Red to both the nylon and velvet areas.

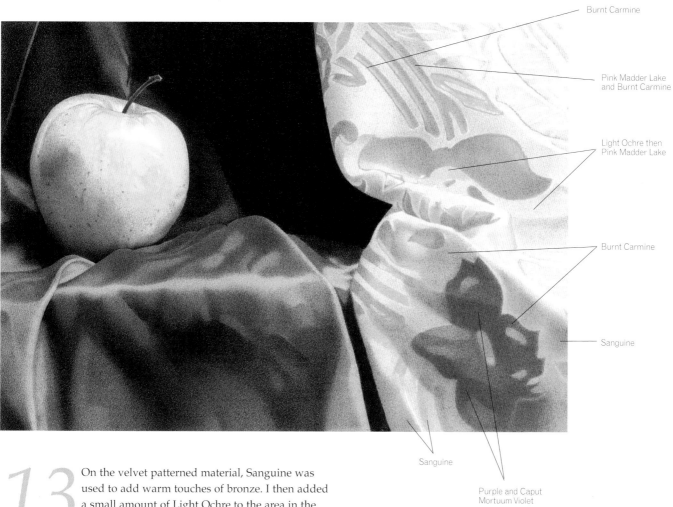

Burnt Carmine

Pink Madder Lake
and Burnt Carmine

Light Ochre then
Pink Madder Lake

Burnt Carmine

Sanguine

Sanguine

Purple and Caput
Mortuum Violet

13 On the velvet patterned material, Sanguine was used to add warm touches of bronze. I then added a small amount of Light Ochre to the area in the top half with a yellow tint, followed by Pink Madder Lake. I also deepened the overall colour of the bottom half of the material using Burnt Carmine. I deepened the colours of the patterned velvet with a combination of Pink Madder Lake and Burnt Carmine on the upper half, and Purple followed by Caput Mortuum Violet on the bottom. I also used Burnt Carmine to add the edges to the velvet shapes, to give them more of a three-dimensional look and to draw in some of the very fine lines to depict the fibres of the velvet. I fixed the drawing and allowed it to dry, and then used Rose Carmine and Middle Cadmium Red to add a final layer of pink to the satin, followed by Wine Red. On the velvet I added a layer of Light Magenta to tone down the lightest highlights, and Light Red Violet to soften the edges of the highlights. Finally, I added a layer of Black Soft to darken the shadow area in the middle of the satin.

Q Having enjoyed the challenge of this project, I would like to set up a similar still life using apples again, but want to change the colour of the material. What would you suggest?

A I came up with apple green because the apple is green and 'apple green' is a colour. The green also contrasts really well with the pinks. You could substitute the green apple for one with touches of red, and change the pink materials for some that contrast well with the apple. To get the colour of the material right, take your chosen apple to a material shop and try it against different colours and patterns, choosing two pieces of material that work well together.

PROJECT ELEVEN: BOBBY

MATERIALS
Pencils
HB pencil
Faber-Castell Polychromos

Black Soft No. 99

Sky Blue No. 146

Burnt Sienna No. 283

Light Orange No. 113

Nougat No. 178

Cold Grey II No. 231

Dark Flesh No. 130

Light Chrome Yellow No. 106

Violet No. 138

Light Purple Pink No. 128

Light Ultramarine No. 140

Blue Violet No. 137

Alizarin Crimson No. 226

Deep Cobalt No. 143

Delft Blue No. 141

Red Violet No. 194

Bistre No. 179

Burnt Umber No. 280

Burnt Ochre No. 187

Fuchsia No. 123

Light Yellow Ochre No. 183

Paper
Smooth Cartridge Paper
210gsm (100lb)

Additional equipment
As for Project One

Aims To capture the alert posture of a long-haired mongrel dog, including the textures of the fur, eye, nose and tongue.

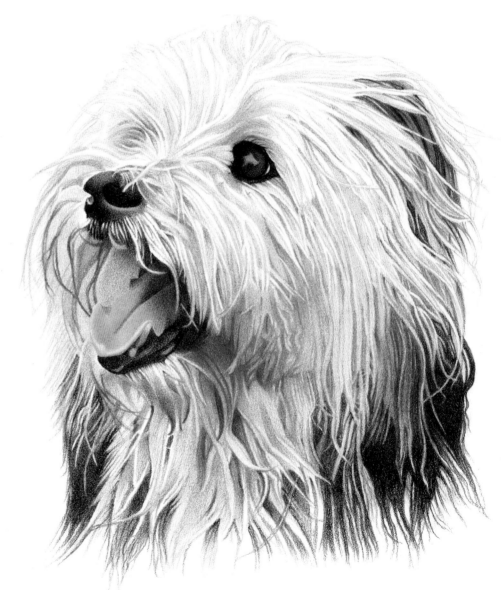

Finished size of my drawing: 14 x 12cm (5½ x 4¾in)

Notes to remember

When attempting a pet portrait, always request as many photos as possible, and ask questions about any unique characteristics or features. Sometimes there may be a very subtle marking on a face but the photo doesn't show it, and be wary of photos taken with a flash, as red-eye can be a major stress to artists. If you are faced with only having a bad photo, look for photos of a similar animal for comparison.

For this project I was fortunate to take the photo myself, by visiting my local dog display team. Bobby was an ideal dog to photograph, as he has been performing for over 16 years and was happy to pose for photos. I love the composition of this one.

In total I took over 36 shots, yet only four were suitable to use as reference. If you are asked to do a commission of a pet, ask if you can take some photos yourself, and take at least two rolls of film.

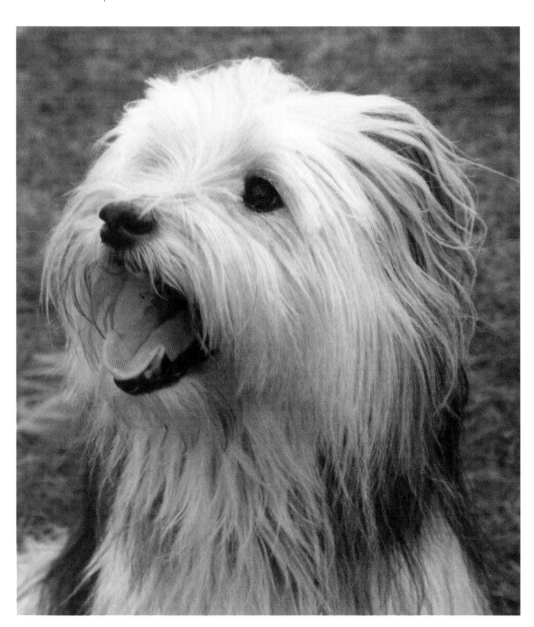

Possible problems with the reference

Inadequate reference material – out-of-focus photos make for hard work.

Getting an interesting pose.

Capturing the character of your subject.

Project Eleven

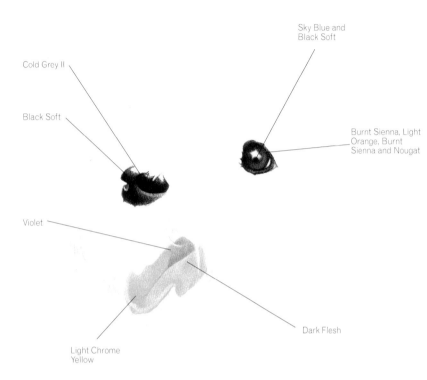

Cold Grey II

Sky Blue and Black Soft

Black Soft

Burnt Sienna, Light Orange, Burnt Sienna and Nougat

Violet

Light Chrome Yellow

Dark Flesh

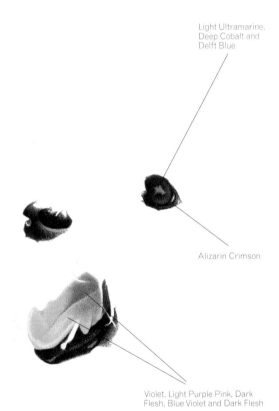

Light Ultramarine, Deep Cobalt and Delft Blue

Alizarin Crimson

Violet, Light Purple Pink, Dark Flesh, Blue Violet and Dark Flesh

1 I started with the eye, using Black Soft to draw the outline. The actual eye is dark brown with a black pupil, but is in shadow. There is a soft highlight in the pupil reflecting the sky, so I added a *soft, light* layer of Sky Blue before adding the pupil using Black Soft – for the brown colouring I used Burnt Sienna, then a *very light* layer of Light Orange, another layer of Burnt Sienna and finally a *very light* layer of Nougat. I then blocked in the nose, using Cold Grey II for the soft black areas, followed by a layer of Black Soft. To block in the tongue I used a *light* layer of Dark Flesh, followed by a *very small* amount of Light Chrome Yellow on the front of the tongue, then a *light* layer of Violet for the shadow area.

2 I deepened the colour of the tongue, adding *light* layers of Violet, Light Purple Pink, Dark Flesh, Blue Violet and another layer of Dark Flesh. I added the lips using Black Soft. When blocking in black lips on a light-coloured dog, it's important to leave the fur reserved as the white of the paper at this stage. I then softened the highlight in the eye using Light Ultramarine, to reflect the colour of the sky, and softened the edges of the highlight using Black Soft. I added a *very fine* line of Alizarin Crimson around the tiny piece of white that can be seen in the outer corner of the eye, and then toned down the highlight with a *soft* layer of Deep Cobalt, followed by a *very soft* layer of Delft Blue.

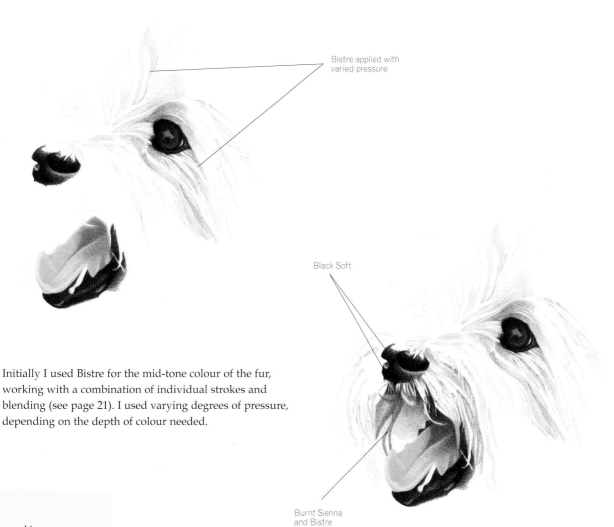

Bistre applied with
varied pressure

Black Soft

Burnt Sienna
and Bistre

3 Initially I used Bistre for the mid-tone colour of the fur,
working with a combination of individual strokes and
blending (see page 21). I used varying degrees of pressure,
depending on the depth of colour needed.

Tip
When working on a
subject that involves
drawing a lot of hairs, I
find it easier if I work on
one area at a time, then
move to another area,
working between and
then joining the two
together. I also use my
spare index finger to
follow the detail on the
reference photo while
drawing, as this helps
me to get everything in
the right place.

4 After working on the fur around the eye, I started to draw
the fur above, on and around the nose, working back
towards the eye and also down towards the mouth. I drew
in individual lines to define the clumps of fur and blocked
in colour using the Bistre. For the fur around the mouth I
introduced Black Soft, adding it to the shadow area on the upper
part of the tongue and to the area just under the upper lip. As the
drawing developed I made alterations to the mouth, adding the
small amount of lip that can be seen on the right-hand side, and
introduced Burnt Sienna for the areas of fur with a reddish tint,
going over this with Bistre.

Project Eleven

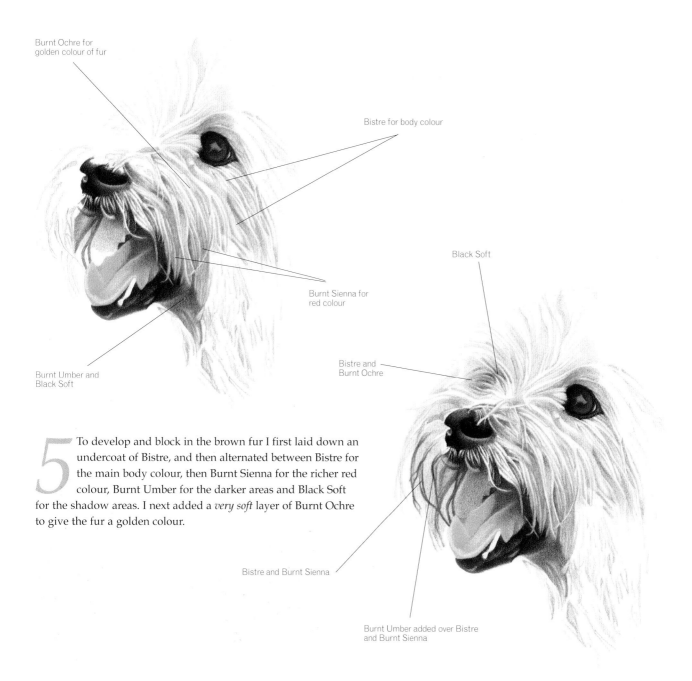

Burnt Ochre for
golden colour of fur

Bistre for body colour

Black Soft

Burnt Sienna for
red colour

Bistre and
Burnt Ochre

Burnt Umber and
Black Soft

Bistre and Burnt Sienna

Burnt Umber added over Bistre
and Burnt Sienna

5 To develop and block in the brown fur I first laid down an undercoat of Bistre, and then alternated between Bistre for the main body colour, then Burnt Sienna for the richer red colour, Burnt Umber for the darker areas and Black Soft for the shadow areas. I next added a *very soft* layer of Burnt Ochre to give the fur a golden colour.

6 I started to work from the right-hand side of the face and ear towards the left-hand side. Because the fur hid the right eye, a subtle touch of pencil mark was called for, and it was important to just suggest the eye using Black Soft. As in Stage 5, Bistre was the main body colour, with a *very soft* touch of Burnt Ochre and Black Soft. For the long fur around the nose I mainly used Bistre followed by Burnt Sienna. Where the fur was particularly dark I added Burnt Umber. For the very light fur on the head I used a *very soft* layer of Bistre.

PROJECT TWELVE: BAND OF GOLD

MATERIALS
Pencils
HB pencil
Caran d'Ache Pablo

Salmon Pink No. 71

Granite Rose No. 493

Brown Ochre No. 37

Hazel No. 53

Salmon No. 51

Cinnamon No. 55

Olive Brown No. 39

Golden Ochre No. 33

Ivory Black No. 496

Olive Black No. 19

Light Ochre No. 32

Umber No. 49

Cream No. 491

Paper
Fabriano 5 HP Paper
600gsm (300lb)

Additional equipment
As for Project One

Aims To draw a pair of hands wearing rings – not only can they be one of the most difficult subjects to draw, but they make an interesting study. This project also introduces another element, metal, into the drawing.

Finished size of my drawing: 9 x 18cm (3¹/₂ x 7¹/₈in)

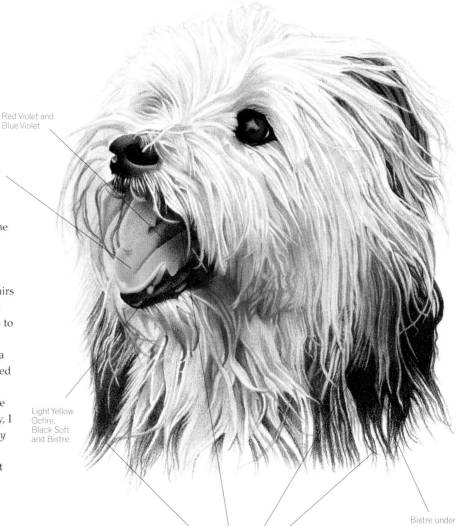

Red Violet and
Blue Violet

Light Purple Pink
and Fuchsia

Light Yellow
Ochre,
Black Soft
and Bistre

Bistre under
Black Soft

Black Soft

10 At this stage I completed the fur to a stage I was happy with, fading it away at the neck as I wasn't going to draw the body. I added some individual hairs to suggest the wiry coat, and deepened the black of the eyelid. The finishing stage was to darken the colour and shadow area of the tongue; I used Light Purple Pink, Fuchsia, a touch of Red Violet and Blue Violet, followed by Black Soft for the shadow area. I also lengthened and squared off the shape of the neckline using Bistre and Black Soft. Finally, I used Light Yellow Ochre, followed by a *very light* touch of Black Soft and then a little Bistre for the two teeth that can be seen just inside the mouth.

Q **I'm drawing a portrait of a friend's dog who died last year, and have been given four photos. Thankfully, there is one that is very clear and with the dog in a great pose, but in each photo the colour of the dog's coat varies from bright orange to beige. What colour should I opt for?**

A That's the problem with photos. The same subject can vary in colour range, depending on the make of the film used, or the different light source the photo was taken in. The person who knows best what the true colour of the dog was is the dog's owner. To save unnecessary stress and work, the easiest solution would be to do a swatch of colours based on the photos and ask the owner to mark the colours that best match those of the dog.

Project Eleven

Tip
When developing areas
that use an alternating
combination of colours,
keep hold of the pencils
in your spare hand. This
makes it easier to
change between them.

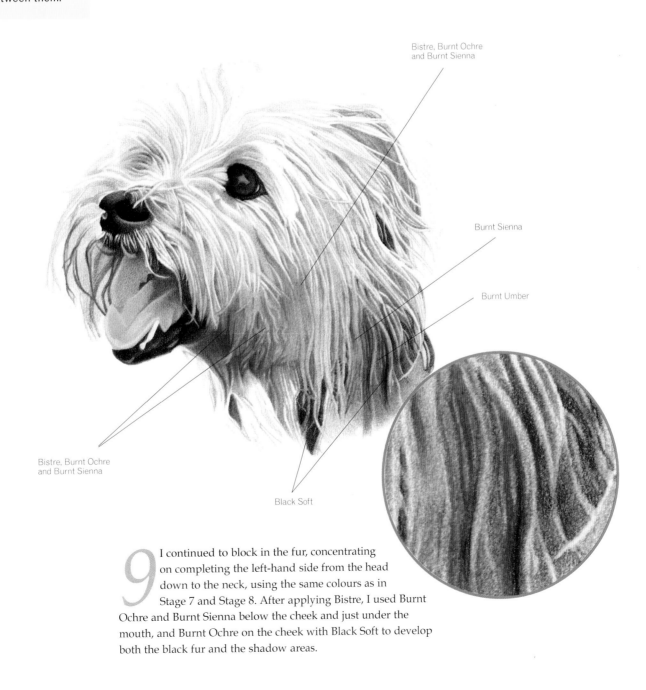

Bistre, Burnt Ochre
and Burnt Sienna

Burnt Sienna

Burnt Umber

Bistre, Burnt Ochre
and Burnt Sienna

Black Soft

9 I continued to block in the fur, concentrating
on completing the left-hand side from the head
down to the neck, using the same colours as in
Stage 7 and Stage 8. After applying Bistre, I used Burnt
Ochre and Burnt Sienna below the cheek and just under the
mouth, and Burnt Ochre on the cheek with Black Soft to develop
both the black fur and the shadow areas.

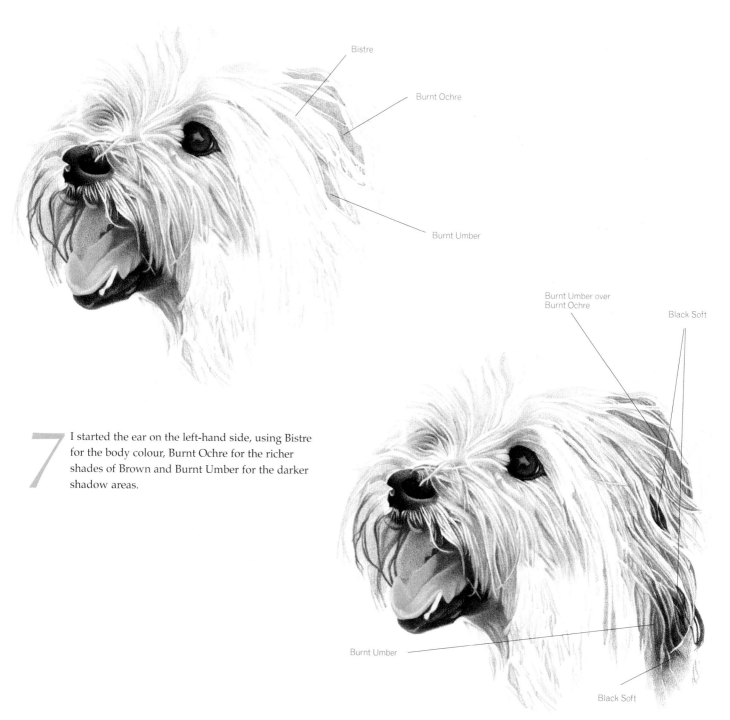

Bistre

Burnt Ochre

Burnt Umber

Burnt Umber over
Burnt Ochre

Black Soft

Black Soft

Burnt Umber

Black Soft

7 I started the ear on the left-hand side, using Bistre for the body colour, Burnt Ochre for the richer shades of Brown and Burnt Umber for the darker shadow areas.

8 I continued to block in the fur. Black Soft was used for the really dark fur that can be seen peeping through the light fur. When using Black Soft it was important to leave the odd light strand of fur showing, so the light fur was initially drawn using Black Soft, with the area on either side being blocked in. This left the strands showing as white, which could then be coloured or toned down using the appropriate colour.

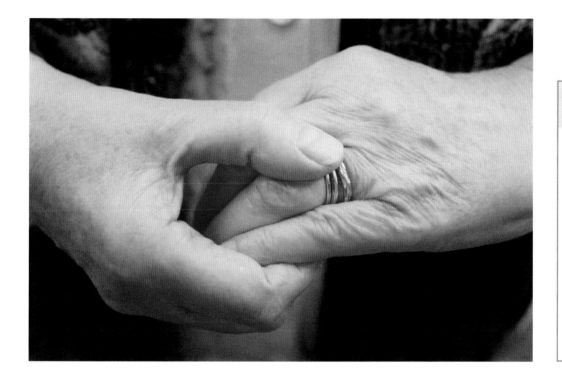

Shape of the fingers –
getting the proportions,
shapes and dimensions
right so that they don't
look like sausages.

Colouring of the flesh – if
using photos, compare
the actual colours of the
hands, as photos can
alter the colours.

If drawing older hands,
getting the wrinkles and
lines to look convincing.

Notes to remember

However well you capture the correct colouring of the
flesh, if the shapes of the fingers are wrong, the whole
drawing will look wrong. What you don't want to end up
with is sausage-shaped fingers. By getting the shape and
angle of the knuckles right from the beginning, the
fingers will look more realistic.

Making lines and wrinkles look convincing and
realistic takes a sharp pencil to capture the fine, delicate
lines. Also, if the contrast in colour between each line
and wrinkle and the surrounding skin isn't strong enough,
the skin will appear too flat. Again, if your pencils aren't
kept sharp, the areas of colour (especially the highlights)

will appear too fuzzy, and not strong or hard as they
should do.

Wanting the hands to belong to an older person,
someone who has lived a long and eventful life, I asked
my mum to pose for me, and I ended up taking over 36
photos. I liked the idea of her toying with her wedding
ring, as though telling a story. To help with the drawing I
printed the photo out on to a transparency, so that I could
use it as a guide.

Project Twelve

Granite Rose applied with
varied pressure

1 I initially traced out the outline of the hands using Salmon
Pink, which I had chosen as my mid-tone colour, and an
HB pencil for the rings. I then blocked in a light base layer
of Granite Rose, leaving the rings as the white of the paper
at this stage. I varied the pressure of the pencil so that I could start
to create the stronger, deeper areas of tone and colour. This helped
to establish the rounded, three-dimensional shape of the hand.

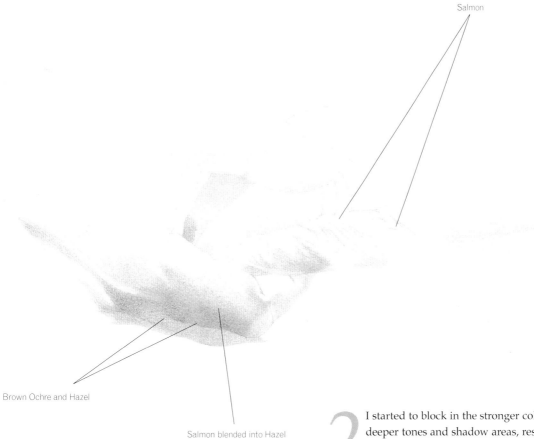

Salmon

Brown Ochre and Hazel

Salmon blended into Hazel

2 I started to block in the stronger colours to develop the deeper tones and shadow areas, reserving some of the previously laid Granite Rose for the ridges of the tendons on the back of the hand. Using Brown Ochre I started the shadow area along the bottom of the right hand, alternating with Hazel to develop the colour. I added Salmon, blending and graduating it with Hazel to create the stronger pink tones. Again using Salmon, I used the transparency to mark some of the lines and wrinkles in the right place and to create the colours of the various creases and tiny folds. I continued to use the transparency for the rest of the drawing for checking the position of the prominent lines and marks.

Project Twelve

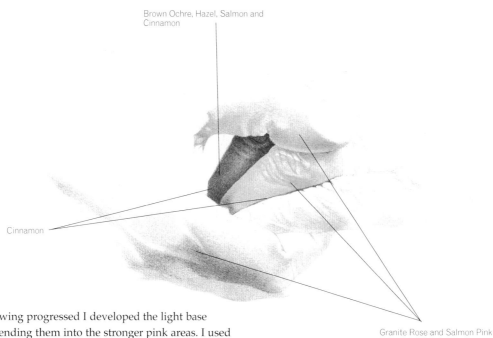

Brown Ochre, Hazel, Salmon and
Cinnamon

Cinnamon

Granite Rose and Salmon Pink

3 As the drawing progressed I developed the light base
colours, blending them into the stronger pink areas. I used
a combination of Granite Rose and Salmon Pink for the
overall base colour, alternating to create the right depth
and tone of colour. For the darker areas I used Brown Ochre, Hazel
and Salmon, and added Cinnamon to warm and deepen the
shadow areas.

Colours applied as for Stage 3

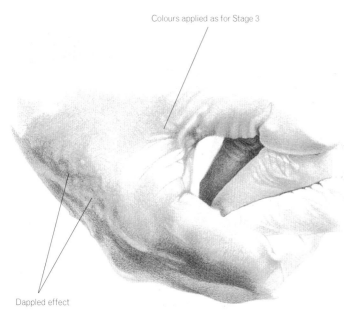

Dappled effect

4 I continued to block in the colours on the right hand. By
this stage it was important to start developing the shape
and texture of the skin further. To create the dappled effect
that can be seen on the back of the hand, I applied the
pencil in delicate, circular movements, barely catching the surface
of the paper. I also started to add more of the Cinnamon to the
shadow areas, applying it over the Brown Ochre.

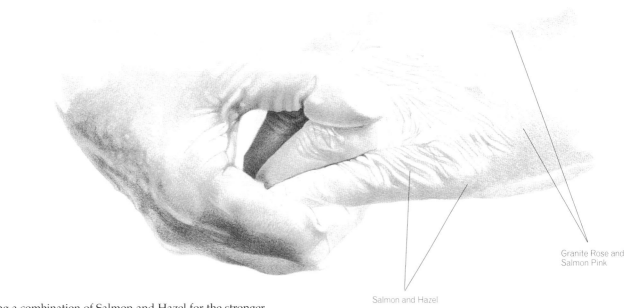

Granite Rose and
Salmon Pink

Salmon and Hazel

5 Using a combination of Salmon and Hazel for the stronger pinks, I blocked in the colour on the hand on the left and drew in the fine lines using Salmon. For the lighter pink areas I used Granite Rose and Salmon Pink.

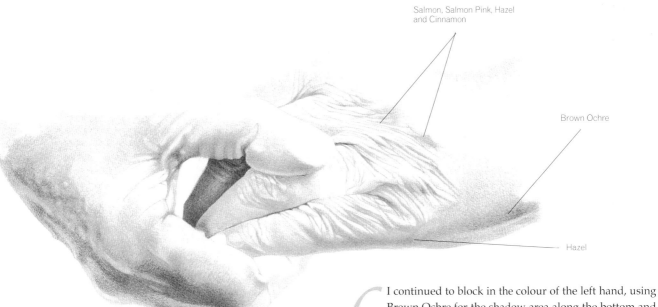

Salmon, Salmon Pink, Hazel
and Cinnamon

Brown Ochre

Hazel

6 I continued to block in the colour of the left hand, using Brown Ochre for the shadow area along the bottom and blending the colour into the medium pink previously laid down. I applied Hazel over the edge of the shadow and graduated it into the pink area, and deepened the colour of the back of the hand using Granite Rose and Salmon Pink, adding a touch of Cinnamon. For the colouring of the shadow area around the knuckles I used a combination of Salmon, Salmon Pink, Hazel and a touch of Cinnamon.

Project Twelve

Olive Brown

Golden Ochre

Tip
Because the shadow areas on the back of the hands are so delicate, keep a putty eraser nearby so that you can gently dab away the pencil from any overworked area.

7 For the rings, the first stage was to block in the colours quite loosely. The gold in this photo contains a lot of green, so I used Olive Brown for those areas and Golden Ochre for the yellow, leaving the strong reflected highlights reserved as the white paper.

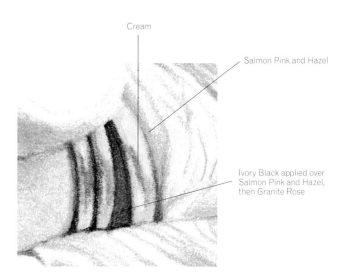

Cream

Salmon Pink and Hazel

Ivory Black applied over Salmon Pink and Hazel, then Granite Rose

Olive Black

Light Ochre

Golden Ochre

8 I then burnished the colours using Cream and reapplied the colours of Stage 7. I deepened the colour of the skin between the rings using Salmon Pink and Hazel, adding a *light* layer of Ivory Black to tone the skin colour down, then added a *light* layer of Granite Rose to make it slightly pink again. I added the shadows between the rings using the Ivory Black, which also helped to smooth the edges of each ring.

9 Going over the rings again, I used Olive Black for the green, Golden Ochre for the dark yellow and Light Ochre for the light yellow. I burnished the greens into the yellow again, using the Cream, and reapplied them lightly. I then reapplied the black shadows and added the markings to the large ring using Olive Black.

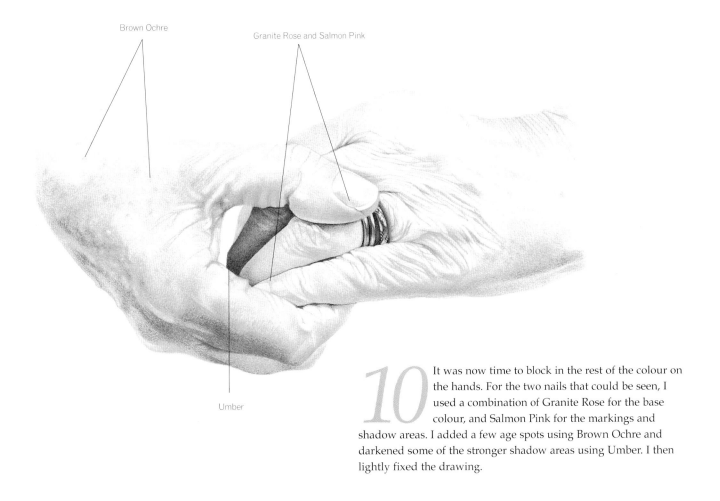

Brown Ochre

Granite Rose and Salmon Pink

Umber

10 It was now time to block in the rest of the colour on the hands. For the two nails that could be seen, I used a combination of Granite Rose for the base colour, and Salmon Pink for the markings and shadow areas. I added a few age spots using Brown Ochre and darkened some of the stronger shadow areas using Umber. I then lightly fixed the drawing.

Q **How do I draw metal and get it to look shiny?**

A Drawing metal is no more difficult than drawing any other material, and should be approached in exactly the same way. You need to study the metal carefully and pick out the colours that match those of the metal. Apply the pencils in blocks of colours, side by side to each other, being careful to leave highlights showing as the white of the paper. Once all the colours are blocked in, burnish (blend) them all together by going over the top with a light pencil to create a smooth look. Then go back over the area to redefine and deepen the colours. Sharp pencils are important, especially when working on a small object such as a ring.

SUPPLIERS

All the products used in this book are available from good-quality art shops or by mail order. For your nearest outlet, or for further information, contact the websites listed below.

Canson Bristol papers
www.canson.com

Caran d'Ache pencils
www. carandache.ch

Derwent pencils and accessories
www.acco.co.uk

Faber-Castell pencils and accessories
www.awfaber-castell.com

Fabriano papers
www.chartae.fabriano.ancona.it

Lyra Rembrandt pencils and accessories
www.lyra-pencils.com

Prismacolor, Verithin and Karismacolor pencils
www.sanfordcorp.com

Zest-It non-toxic solvent
www.zest-it.com

ACKNOWLEDGEMENTS

My sincere thanks to Sarah Hoggett, for giving me this opportunity of fulfilling a lifetime ambition of writing an art-technique book.

To the editors and designers at David & Charles for their continued help and guidance in making my task a whole lot easier.

To my family, especially my partner Dave, for their love and support since I turned professional as an artist three years ago, and especially during the writing of this book, when their understanding and patience were invaluable.

Last, but by no means least, to my students, past, present and future, for allowing me to share my techniques with them. A shared love of using coloured pencils makes teaching a pleasure and a joy.

INDEX